P·R·A·C·T·I·C·A·L

Calligraphy

TECHNIQUES AND MATERIALS

P·R·A·C·T·I·C·A·L
Calligraphy
TECHNIQUES AND MATERIALS

TIGER BOOKS INTERNATIONAL
LONDON

A QUINTET BOOK

This edition first published 1990 by
Tiger Books International Ltd.
London

This book was designed and produced by
Quintet Publishing Limited
6 Blundell Street
London N7 9BH

Creative Director: Peter Bridgewater
Art Director: Ian Hunt
Designers: Stuart Walden, Nicki Simmonds
Project Editor: Mike Darton
Editor: Belinda Giles
Artwork: Jenny Millington

Typeset in Great Britain by
Central Southern Typesetters, Eastbourne
Manufactured in Hong Kong by
Regent Publishing Services Limited
Printed in Hong Kong by
Leefung-Asco Printers Limited

The material in this publication previously
appeared in *The Calligraphy Source Book*,
*The Complete Guide To Calligraphy Techniques and
Materials* and *An Introduction To Calligraphy*.

Acknowledgements

l=left, r=right, c=centre, top=top, b=below

Alex Arthur: 18br, 19b; Paul Arthur: 18bl; Arthur Baker: 42, 98, 124, 141; Rupert Bassett: 19t; Hella Basu: 29tl; Robert Boyajian: 37; Gunnlaugur SE Briem: 134; British Library: 14t, 20, 24, 135; Jagjeet Chaggar: 108; Heather Child/Permission: 33; Ursula Dawson: 16, 18tl; Evert van Dijk, Gaade Uitgevers: 129; Timothy Donaldson: 32–125; Dover Publications: 55, 90–3, 112–5, 121; George Evans: 39, 44–5, 48–50, 57–60, 62, 63tl&r, 64–75, 78–89, 101–3, 109–11, 116–19, 130–2, 136–8, 140; Mary Evans: 41; Fotomas: 27; Michael Freeman: 18tr; Sally Giles: 100; Anne Hechle: 139l; Karlgeorg Hoefer: 29tr; Michael Holford: 10, 11; Donald Jackson: 40; Dorothy Mahoney: 104–5; Pitman Publishing: 96–7, 99; Terry Paul: 139r; Quill: 30–1, 36, 43r, 46, 133; Imre Reiner: 29b; Ronald Sheridan's Photo Library: 14b, 15, 17, 22; Erkki Ruuhinen: 53t; Werner Schneider: 76–7, 94–5, 122–3; Carol Thomas: 107; Peter Thompson: 52, 120; V&A Museum: 23, 25, 26, 53b; Alan Wong: 43l; John Woodcock: 140; Herman Zapf: 28.

Contents

Introduction

The earliest evidence of a written hand is a limestone tablet of around 3500 BC, which is made up from pictograms. These pictograms developed into ideograms – pictures representing ideas or less definite objects. Finally, phonograms were used – symbols representing the sounds of language.

The roots of our present-day letters, however, are to be found in the Roman alphabet of the 1st century AD. These majuscule – or capital – letters were mainly incised into stone with a chisel, and probably owe their shape to this fact.

Calligraphers and letter designers are still emulating the incised square capital, despite the evolution of many derived styles and variations in received traditions. In virtually all, the very shape of a square-ended implement utilized in producing letterforms remains evident in their starting and ending points. Moreover, many styles said to have evolved through a desire for speed are unbelievably elaborate for their intended purpose. If speed were indeed of the essence, surely the fewer the strokes, the more efficient the style? It must therefore be accepted that calligraphic forms are rarely written for ease or with communication as the primary factor: more often than not, artistic appearance is given priority over the need even for legibility.

Few people who pick up a calligraphic pen for the first time ever produce a masterpiece. Many are so disappointed with the results that they give up. After all, lettering and calligraphy would seem just to be an extension of handwriting, taught in school from an early age. This is far from the truth. Dedication and an appreciation of letterforms and space are essential in this most disciplined of arts.

Although each letter in an alphabet has its own trait, there are elements that are common to each letter, giving uniformity and continuity to the lettering. The student should try to become aware of the main characteristics of a style before lettering is commenced. The round letters will, for example, all have similarities in weight of stroke and curvature; a pattern will likewise emerge in comparing straight and oblique strokes. The alphabet as a whole should appear in complete harmony, without anomalies.

This book aims to assist anyone who is interested in becoming proficient with a pen. More than that, it invites him or her to become aware of the letterforms that surround us all in our everyday lives, and especially if we live and work in a town or city. Provided that the student is willing and – above all – patient, by the end of this book he or she should be well on the way to experiencing the genuine enjoyment of calligraphy.

Glossary

ARCH The part of a LOWER-CASE letter formed by a curve springing from the STEM of the letter, as in h, m, n.

ASCENDER The rising stroke of a LOWER-CASE letter.

BASE LINE Also called the writing line, this is the level on which a line of writing rests, giving a fixed reference for the relative heights of letter and the drop of DESCENDERS.

BLACK LETTER The term for the dense, angular writing of the GOTHIC period.

BODY HEIGHT The height of the basic form of a LOWER-CASE letter, not including the extra length of ASCENDERS or DESCENDERS.

BOOK HAND Any style of alphabet commonly used in book production before the age of printing.

BOUSTROPHEDON An arrangement of lines of writing, used by the Greeks, in which alternate lines run in opposite directions.

BOWL The part of a letter formed by curved strokes attaching to the main STEM and enclosing a COUNTER, as in R, P, a, b.

BROADSHEET A design in calligraphy contained on a single sheet of paper, vellum or parchment.

BUILT-UP LETTERS Letters formed by drawing rather than writing, or having modifications to the basic form of the structural pen strokes.

CALLIGRAM Words or lines of writing arranged to construct a picture or design.

CAROLINGIAN SCRIPT The first standard MINUSCULE script, devised by Alcuin of York under the direction of the Emperor Charlemagne at the end of the eighth century.

CHANCERY CURSIVE A form of ITALIC script used by the scribes of the papal Chancery in Renaissance Italy, also known as *cancellaresca*.

CHARACTER A typographic term to describe any letter, punctuation mark or symbol commonly used in typesetting.

CODEX A book made up of folded and/or bound leaves forming successive pages.

COLOPHON An inscription at the end of a handwritten book giving details of the date, place, scribe's name or other such relevant information.

COUNTER The space within a letter wholly or partially enclosed by the lines of the letterform, within the BOWL of P, for example.

CROSS-STROKE A horizontal stroke essential to the SKELETON form of a letter, as in E, F, T.

CUNEIFORM The earliest systematic form of writing, taking its name from the wedge-shaped strokes made when inscribing on soft clay.

CURSIVE A handwriting form where letters are fluidly formed and joined, without pen lifts.

DEMOTIC SCRIPT The informal SCRIPT of the Egyptians, following on from HIEROGLYPHS and HIERATIC SCRIPT.

DESCENDER The tail of a LOWER-CASE letter that drops below the BASELINE.

DIACRITICAL SIGN An accent or mark that indicates particular pronunciation.

DUCTUS The order of strokes followed in constructing a pen letter.

FACE abb **TYPEFACE** The general term for an alphabet designed for typographic use.

FLOURISH An extended pen stroke or linear decoration used to embellish a basic letterform.

GESSO A smooth mixture of plaster and white lead bound in gum, which can be reduced to a liquid medium for writing or painting.

GILDING Applying gold leaf to an adhesive base to decorate a letter or ORNAMENT.

GOTHIC SCRIPT A broad term embracing a number of different styles of writing, characteristically angular and heavy, of the late medieval period.

HAND An alternative term for handwriting or SCRIPT, meaning lettering written by hand.

HAIRLINE The finest stroke of a pen, often used to create SERIFS and other finishing strokes, or decoration of a basic letterform.

HIERATIC SCRIPT The formal SCRIPT of the ancient Egyptians.

HIEROGLYPHS The earlist form of writing used by the Ancient Egyptians, in which words were represented by pictorial symbols.

IDEOGRAM A written symbol representing a concept or abstract idea rather than an actual object.

ILLUMINATION The decoration of a MANUSCRIPT with gold leaf burnished to a high shine; the term is also used more broadly to describe decoration in gold and colours.

INDENT To leave space additional to the usual margin when beginning a line of writing, as in the opening of a paragraph.

IONIC SCRIPT The standard form of writing developed by the Greeks.

ITALIC Slanted forms of writing with curving letters based on an elliptical rather than circular model.

LAYOUT The basic plan of a two-dimensional design, showing spacing, organization of text, illustration and so on.

LOGO A word or combination of letters designed as a single unit, sometimes combined with a decorative or illustrative element; it may be used as a trademark, emblem or symbol.

LOWER-CASE Typographic term for 'small' letters as distinct from capitals, which are known in typography as upper-case.

MAJUSCULE A capital letter.

MANUSCRIPT A term used specifically for a book or document written by hand rather than printed.

MASSED TEXT Text written in a heavy or compressed SCRIPT and with narrow spacing between words and lines.

MINUSCULE A 'small' or LOWER-CASE letter.

ORNAMENT A device or pattern used to decorate handwritten or printed text.

PALEOGRAPHY The study of written forms, including the general development of alphabets and particulars of handwritten manuscripts, such as date, provenance and so on.

PALIMPSEST A MANUSCRIPT from which a text has been erased and the writing surface used again.

PAPYRUS The earliest form of paper, a coarse material made by hammering together strips of fibre from the stem of the papyrus plant.

PARCHMENT Writing material prepared from the inner layer of a split sheepskin.

PHONOGRAM A written symbol representing a sound in speech.

PICTOGRAM A pictorial symbol representing a particular object or image.

RAGGED TEXT A page or column of writing with lines of different lengths, which are aligned at neither side.

RIVER The appearance of a vertical rift in a page of text, caused by an accidental, but consistent, alignment of word spaces on following lines.

ROMAN CAPITALS The formal alphabet of capital letters, devised by the Romans, which was the basis of most modern, western alphabet systems.

RUBRICATE To contrast or emphasize part or parts of a text by writing in red; for example, headings, a prologue, a quotation.

RUSTIC CAPITALS An informal alphabet of capital letters used by the Romans, with letters elongated and rounded compared to the standard square ROMAN CAPITALS.

SANS SERIF A term denoting letters without SERIFS or finishing strokes.

SCRIPT Another term for writing by hand, often used to imply a CURSIVE style of writing.

SCRIPTORIUM A writing room, particularly that of a medieval monastery in which formal manuscripts were produced.

SERIF An abbreviated pen stroke or device used to finish the main stroke of a letterform; a hairline or hook, for example.

SKELETON LETTER The most basic form of a letter demonstrating its essential distinguishing characteristics.

STEM The main vertical stroke in a letterform.

TEXTURA A term for particular forms of GOTHIC SCRIPT that were so dense and regular as to appear to have a woven texture. *Textura* is a Latin word, meaning 'weave'.

TRANSITIONAL SCRIPT A letterform marking a change in style between one standard SCRIPT and the development of a new form.

UNCIAL A BOOKHAND used by the Romans and early Christians, typified by the heavy, squat form of the rounded O.

VELLUM Writing material prepared from the skin of a calf, having a particularly smooth, velvety texture.

VERSAL A large, decorative letter used to mark the opening of a line, paragraph or verse in a MANUSCRIPT.

WEIGHT A measurement of the relative size and thickness of a pen letter, expressed by the relationship of nib width to height.

WORD BREAK The device of hyphenating a word between syllables so it can be split into two sections to regulate line length in a text. Both parts, ideally, should be pronounceable.

X-HEIGHT Typographic term for BODY HEIGHT.

The history of
Calligraphy

One of the oldest civilizations of which we have evidence was that of the Sumerians, who inhabited the fertile region of Mesopotamia around the rivers Tigris and Euphrates, an area which now falls within the boundaries of modern Iraq. Their agricultural society was highly organized, using irrigation from the rivers and making use of domesticated animals in farming. From the fourth century BC until they were overrun by the Babylonians in 1720BC, the Sumerians established towns and cities, set up a basic system of regional government and were sufficiently prosperous for citizens to perform services beyond the basic requirements of agriculture and trade, such as skilled crafts and medicine.

The earliest evidence of a writing system in Sumer is a limestone tablet from the city of Kish, dating to about 3500BC. This shows several pictograms, including a head, foot and hand. Pictograms are pictorial symbols that directly represent a particular object. Gradually, by association, the symbol could represent a less concrete image – the sun, for example, could also stand for 'day'. A symbol extended in this way is known as an ideogram. The Sumerians at one time had about 2,000 such symbols forming the elements of their written language. A further development occurred when it was realized that a symbol representing one word could also be used for a similar sounding word, and that such symbols could be put together to form composite words, by reference to syllabic sounds. These phonograms, or symbols representing sounds, were freed from the original, illustrative conventions of pictograms. This meant that the number of symbols could be reduced and their forms stylized. The essence of an alphabet system had come into being.

The Sumerians mainly used soft clay as a writing surface, inscribed with a stick or reed stylus. Drawing on clay is difficult because ridges of clay build up in front of the tool; the symbols tend to be more angular because curved shapes are so difficult to form. The Sumerians gradually evolved the method of pressing the stylus into the clay in a series of small marks. The impression of the stylus left wedge-shaped marks; Sumerian writing is known as cuneiform, from the Latin word *cuneus* meaning 'wedge'. Speed in writing also reduced the complexity of individual symbols and increased the tendency to abstraction.

To prevent the clay from hardening before the writing was finished, small tablets were used for note-taking in business and administrative affairs; important data were then transferred to a more permanent record. The small note-tablets could be held in one hand while written on with the other. This gave a slanted direction to the symbols, towards the left-hand edge of the tablet. This was later incorporated into the formal, conventionalized cuneiform signs, giving them a definite horizontal emphasis. (Most of the evidence of early writing styles also suggests that throughout history the majority of people have been right-handed.)

The development of Egyptian civilization was concurrent with that of the Sumerians; Egypt upheld its cultural traditions through centuries of peace, war and invasion before collapsing under external influences. Egypt was, like Sumer, a well-organized agricultural society with a system of central government, land ownership and taxation that generated much administrative work. From about 3000BC the Egyptians used a form of picture writing known as hieroglyphics, meaning 'sacred, carved writing'. Within 200 years a script had been developed, known as hieratic script. A thousand years later a less formal script, known as demotic, was also in use. Hieratic evolved as a simplified version of hieroglyphics, whereas demotic was a cursive, practical hand.

The Egyptians, like the Sumerians, had developed their writing through pictograms to ideograms and then phonograms. By 1500BC

The earliest writing was in pictograms, the best-known example of which is Egyptian hieroglyphics. This example (right) is from a relief found in a tomb at Sakkara, probably dating from the 5th Dynasty (2560– 2420BC). The Hittites, who founded a powerful ancient civilization in Asia Minor between three and four thousand years ago, also used a form of hieroglyphics (centre). This Assyrian script, typical of the period between the eighth and ninth centuries BC, was used in many copies of earlier texts made in the seventh century BC for Assurbanipal's Royal Library in Nineveh (left). By the time of the Greeks, a recognizable alphabet had been developed. This writing, relating omens derived from the flight of birds, is from Ephesus and dates from the sixth century BC (bottom right).

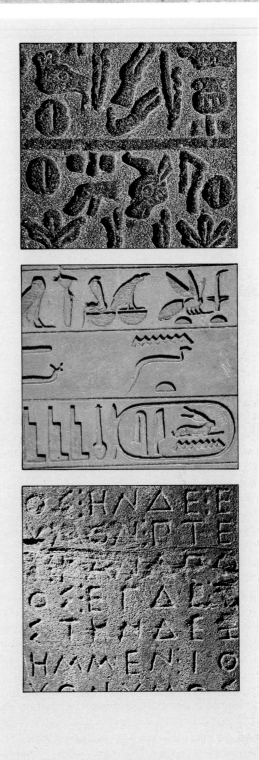

they had established an alphabet of 24 consonantal symbols, although this was never fully detached from the hieroglyphs and ideograms; the various forms were written together or side by side, as if to ensure that the text could be understood one way or another.

A major influence on the development of form in Egyptian writing was their use of reed brushes with liquid ink to paint the pictograms and signs, instead of relying on inscribed symbols. Further, they wrote on papyrus, a thin, flexible fabric, rather than stone, clay or wood, although those materials were cheaper, everyday alternatives. Prepared animal skins were even more expensive than papyrus and were reserved for documents of outstanding importance. The written papyri were rolled for storage and reading convenience. Until the 12th Dynasty (1991–1786BC) the writing was arranged in vertical lines and the sequence ran from right to left. After this period lines were arranged horizontally in narrow, vertical columns, but still read from right to left.

The Egyptians were the first civilization to have official scribes and a system of education that required the tedious copying of sample writing and admired pieces of literature. Trainee scribes and the sons of noblemen had to spend days memorizing the innumerable signs and the sequences of the writing. Nevertheless, this is indicative of the value Egyptians placed on literacy and the dissemination of knowledge; although many of the scribes were slaves, they were rigorously trained to carry out their particular duties.

In the time of Ptolemy I (323–285BC) the official court language was Greek, and Alexandria became a centre of learning based on Greek scholarship. The Egyptian 24-letter alphabet is thought to have had some bearing on the rather different and certainly more advanced alphabet of the Semitic tribes of eastern Mediterranean lands. These tribes then passed their own alphabet to the Greeks, where it was graduallly adapted to form the basis of the alphabet used today in the western world.

The most influential people among the Semitic tribes were the Phoenicians, who lived on

Rustics 1st to 3rd C. AD

Square Capitals 1st to 4th C. AD

Roman 1st C. AD

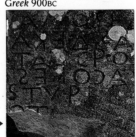

Greek 900BC

Ideogram/Pictogram

Cuneiform 3500–2000BC

Hieroglyph 3000BC

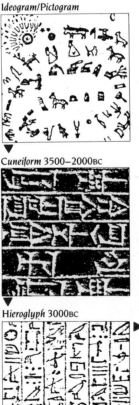

This chart shows the chronological development of the alphabet and the evolution in styles of writing. Starting with the earliest forms of recorded language, the pictograms, ideograms and hieroglyphs of ancient civilizations, it demonstrates the gradual emergence of wholly abstract symbols representing sounds of speech and the establishment of the versatile but relatively few characters constituting the Roman alphabet, the division of capital letters and minuscule scripts, and the subsequent stylistic variations.

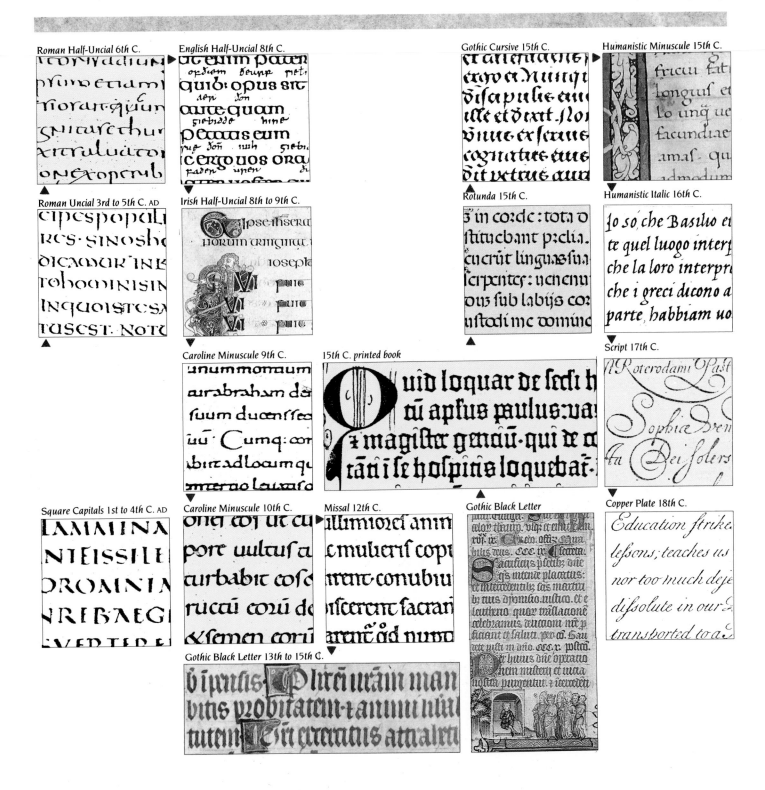

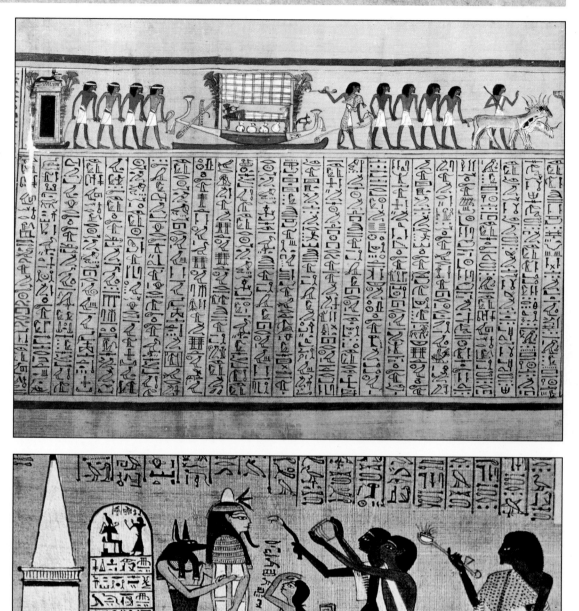

Pictorial hieroglyphs were retained in ancient Egypt long after a linear script had been developed. Skill and scholarship were needed to master the written language and scribes took pride in the careful design of a wall inscription or long papyrus roll. Each sign represented a word but hieroglyphs also employed what is known as the rebus device; two symbols combined according to the sounds they represent to produce a separate two-syllable word. There were strict conventions governing the form of both painting and writing. Much Egyptian art was concerned with rituals of death and burial, highly significant in their religion and culture. This section of the Papyrus of Ani from the Book of the Dead shows the mummy being escorted to the tomb.

This Egyptian manuscript decoration is taken from the Book of the Dead, 1300BC. The scene represents the ceremony of 'opening the mouth', and is written on papyrus.

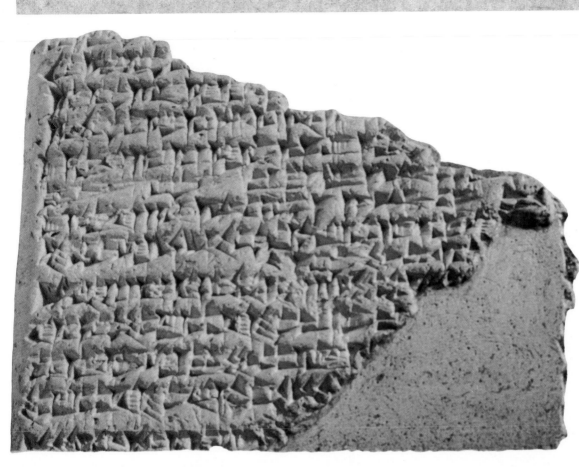

The characteristic wedge-shaped marks of cuneiform writing are clearly preserved in this account of the birth of King Sargon of Akkad, dating from the third millenium BC. Akkad, a city on the Euphrates river, was a centre of early Mesopotamian civilization. Much written information has survived from that period; apart from historical records, there are many tablets giving details of day-to-day business.

the Levantine coast of the Mediterranean (now Lebanon and Syria). Their civilization was contemporary with the rise of the Egyptian Old Kingdom from 2700BC. The Phoenicians were a skilled and intelligent people, energetic traders, with a merchant fleet that sailed as far as the shores of Britain in the interests of business and commerce.

The oldest known alphabetic inscription of the Phoenicians dates from 1000BC. It is not known precisely how their symbols were evolved, but there are ancestral links with Sumerian pictography and the cuneiform symbols taken over by the Babylonians. There were a number of different Phoenician settlements and local variations of written forms. However, by 1000BC there was at least one alphabet system in existence with only 30 symbols, each sign representing a single consonantal sound. These symbols were entirely abstract, not sug-

gestive of pictures or associative ideograms. Phoenician culture survived a period under the Assyrians, who conquered and took control of their land from 850 to 722BC. The Phoenician alphabet emerged intact from this experience and was passed on to the Greeks in the form of 24 consonantal signs. It was also influential as the basis of Persian and Arabic scripts.

The classical period

The Greeks adopted the Phoenician alphabet some time before 850BC. There had been an earlier form of Greek writing, originating from Cretan scripts of 2500BC and later. This, however, had disappeared by 1200BC as far as can be judged from surviving inscriptions, and it appears that by the time they started developing their own alphabet on the Phoenician model,

the Greeks were largely unaware of the earlier writing system. The historian Herodotus (active 484–425BC) describes the Phoenician contribution as follows: 'The Phoenicians . . . introduced into Greece, after their settlement in the country, a number of accomplishments, of which the most important was writing, an art till then, I think, unknown to the Greeks. At first they used the same characters as all the other Phoenicians but as time went on, and they changed their language, they also changed the shape of their letters.'

The modifications made to the alphabet by the Greeks were necessary because the Phoenician language was basically consonantal and not all the signs they used were applicable to the spoken form of Greek. The Greeks, therefore, adapted certain symbols to stand for vowel sounds instead of their original consonantal value. *Aleph*, an aspirant H sound in Phoenician, was converted to the vowel sound A and renamed *alpha* by the Greeks. (*Aleph* originally meant 'ox' and its written symbol was based on a simple drawing of an ox's head.) The first two letters of the Greek series, *alpha* and *beta*, have given us the term by which we describe the basic lettering system, the alphabet.

By 400BC a standard Greek script, called Ionic, had been developed to replace all local variations on the Phoenician forms. The Greeks at first used brushes for writing as the Egyptians had centuries – even millennia – before them,

The clean proportions of Roman squared capitals are preserved in stone-carved monumental inscriptions, such as this senatorial address in honour of the Emperor Augustus (below), found damaged but still legible in the forum at Rome. The weight of the lettering and subtle thick/thin variation in the strokes is perfectly maintained through both the large and smaller-scale letters.

and wrote in horizontal lines from right to left. As they began to use reed pens more frequently, it became conventional to work from left to right, since for a right-handed scribe the pen moves more freely in that direction and the writing hand does not obscure the line of text. Briefly, in between, there was a form known as *boustrophedon*, where the lines ran alternately in opposite directions and the lettering was itself reversed in the reversed lines. *Boustrophedon* means 'following the ox furrow' and referred to the back and forth movement of a plough across a field.

The Greeks used papyrus and skin as writing materials, but wax tablets were also common. Wax enabled swift corrections to be made as the surface could be rubbed to smooth and melt away the inscription. The forms of Greek writing in early papyri were squared and angular, echoing the carved letters, but they soon gave way to more rounded forms and informal, cursive writing styles also quickly developed.

The Romans had occupied the land around the River Tiber from about 1000BC, but their development as a nation proceeded slowly and was interrupted by Etruscan invasion, followed by an occupation that lasted from the seventh to the third century BC. Regaining control of their land, the Romans progressed rapidly, eventually becoming the most powerful people in the known world.

The Romans adopted certain characters from

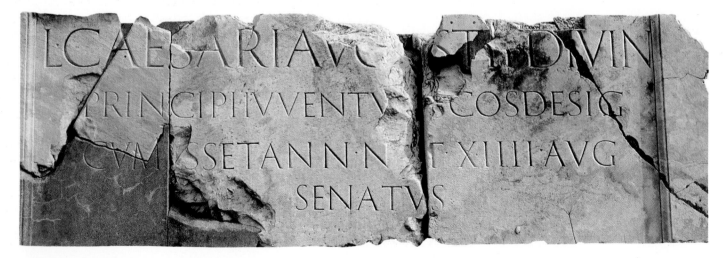

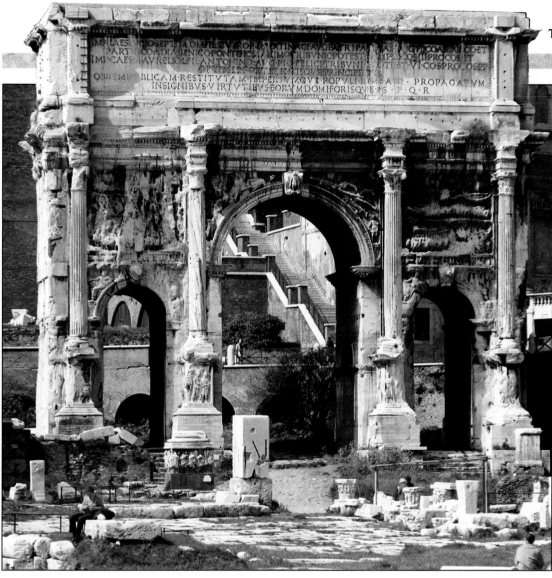

Monumental inscriptions were carefully planned and executed according to the importance of the words and available space, as shown by this example from the arch of Septimius Severus in Rome.

the Greek alphabet almost without modification (A B E H I K M N O X T Y Z). They remodelled others to suit their own language (C D G L P R S) and revived three symbols discarded by the Greeks (F Q V). By the dawn of the Christian era they had established not only this formal alphabet of a fixed number of signs, but also several different ways of writing it. Roman square capitals, the *quadrata*, are the elegant, formal letters seen on monumental inscriptions in stone; they were also drawn with brush and pen, but the fine, serifed forms of the inscriptional writing owe much to the action of the chisel. A less formal, more quickly written version was Rustic capitals, compressed, vertically elongated characters with softer lines. This

became the main book hand of the Romans and was more economical than the squared, generously spaced *quadrata*. A cursive majuscule script evolved from the formal capitals and several variations of informal cursive script came into being. These were all standard forms within the Roman Empire by the first century AD. Greece had become a province of the Roman Empire by 146BC and Greek was retained as the language of scholarship, and for daily use in the ordinary communications of Greek-speaking settlements.

As the Roman Empire proceeded with its vast business of government and trade, there were many administrative centres employing professional scribes and much demand for the

Fragments of Greek (far right) and Roman (right) lettering in stone show the similarity of certain letterforms and the way in which the Romans developed a more formal, stately interpretation as the full alphabet sequence evolved. The slight roughness of the Greek letters indicates the difficulty of carving the linear forms into stone, a skill which the Romans brought to a high art. The channels of the letter strokes in this inscription from the triumphal arch of Claudius, dating from the first century BC, were originally filled with bronze.

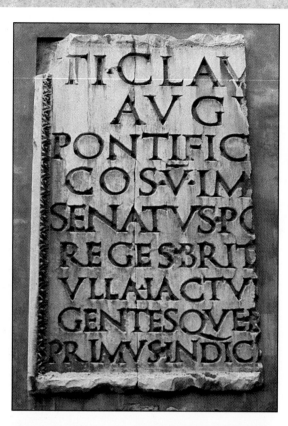

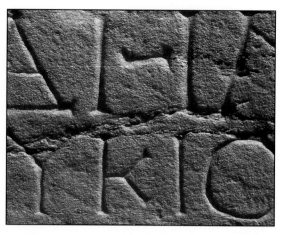

skills of writing and carving letters. A high proportion of the Roman population was literate and writing was an important method of communication at all levels. Papyrus was used everywhere, making its manufacture and distribution crucial to the economy of Rome. The wax tablets used by the Greeks were also adopted, and public inscriptions of a temporary nature, such as political notices, were painted on walls in Rustics. Examples of these can be

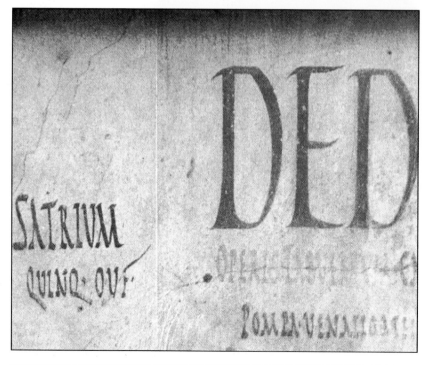

The prevalence of Roman lettering on a wide range of artefacts testifies to a relatively literate, organized society.

Left: Informal street notices, such as this first-century graffiti from Pompeii, were painted on walls with brushes.

Below: Roman coins featured low reliefs of emperors' heads, symbols of the state and inscriptions.

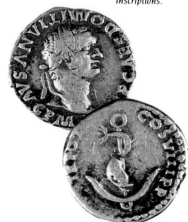

Below: Bronze letters, such as this A, were inlaid in stone-carved inscriptions.

The classical art of lettering is recovered in this modern reworking of Roman capitals (above), in this instance carved in the more yielding material of plaster rather than stone, but still finely calculated in the proportions and relationships of the letters.

found in the lava-covered ruins of Pompeii.

The economy of this alphabet system lies in being able to construct such a great variety of syllabic combinations from the restricted number of symbols. The letter A, for example, can be used to convey seven different sound values, while I has some 23 phonetic valuations. With the peak and decline of the Roman Empire, the development of writing lay entirely within this framework, although during the medieval period, three additional letterforms – J, U and W – were inserted to distinguish certain sounds previously associated solely with the letters I and V.

The most crucial influence upon the further development of writing, but concerned entirely with style and materials, was the rise of Christianity. This became the official religion of the Roman Empire in 311AD. In Egypt, which had become a province of Rome in 30BC, Christian influence closed schools and temples and caused the final demise of the hieroglyphic heritage. While the influence of the Phoenician alphabet elsewhere developed towards modern Hebrew and Islamic script, so the activities of missionaries throughout the Roman Empire spread Christianity across Europe and founded the traditions of western civilization.

The development of minuscule scripts

Two main developments in writing took place towards the end of the Roman period, one technical, the other formal. The papyrus rolls that had formed the books of Egypt, Greece and Rome were gradually replaced by codex books, which consisted of folded leaves bound together in the form that books take today. These may have derived from the everyday use of wax tablets framed in wood, which were often bound together with leather thongs to produce successive 'pages'. Early codex books put together in this way have been found with a combination of papyrus and parchment leaves. This form was superseded by the use of animal skins for all the pages, because parch-

ment and vellum could be sharply creased, unlike papyrus which cracks when folded. Codex books were far more convenient than the long, rolled papyri, which could only be written on one side, because the outer surface was exposed to continual handling. It was also difficult to find a specific place in a long text while unravelling a continuous sheet.

As parchment and vellum became the standard material of books, the quill pen superseded the heavier reed. Since the animal skin surface could be made smooth and velvety, unlike the fibrous papyrus, the delicate quill suffered no immediate damage and scribes soon learned to shape and trim the quill to a suitable form. Like the reed, the quill was naturally equipped with a hollow barrel that retained a small reservoir of ink. The use of quills became a practical necessity in the further reaches of the Roman Empire, where they were simply more plentiful than the suitable reed. It should be noted, however, that the use of vellum and the quill pen was for a long time reserved for particularly important documents and the use of wax tablets in everyday transactions and records continued over several centuries.

By the fourth century AD the Romans had developed a new script, the uncial, which became the main book hand of Roman and early Christian writings, continuing until the eighth century. The term uncial was first applied to the script in the eighteenth century and derives from *uncia* meaning 'one inch'. The new script was a modification of square capitals, possibly based on cursive majuscule forms used in business records and contracts. The characters A D E H and M, however, were rounded, D and H having brief rising strokes like the ascenders of later minuscule forms. The uncial was then followed by the half-uncial. Here for the first time, certain letters broke through the writing lines with noticeable ascenders and descenders. This was a formalization of cursive styles that had developed in day-to-day use and were modified as writing became speedier. Half-uncial script was secondary to uncial and both were later replaced by formal minuscule

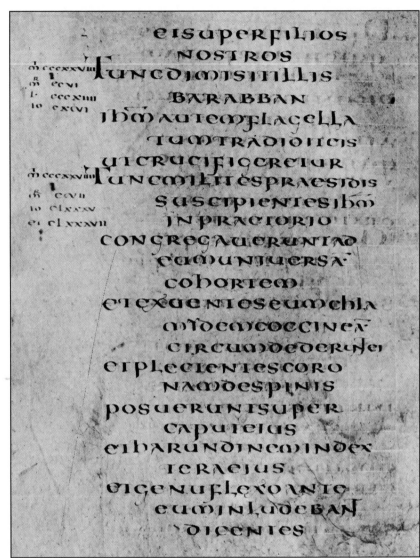

alphabets. All the Roman letterforms show the influence of the square-edged pen, which may be seen in the characteristic graduation of thick and thin strokes.

Uncials and half-uncials were taken to monastic settlements in the north and west of the Roman Empire by Christian evangelists and missionaries. In Ireland and the north of England they developed into what have become known as the Insular scripts. The tradition evolved of writing the gospels in the form of highly decorated codex books; two of the finest

are the Lindisfarne Gospels, written in the northern English monastery of Lindisfarne some time after the death of St Cuthbert in 687 AD, and the Irish Book of Kells, probably written by monks on the island of Iona at the end of the eighth century. The Book of Kells, which was never actually completed, also provides much interesting evidence of the writing and decoration techniques employed by the early scribes.

These English and Irish half-uncials technically remained majuscule scripts; they were preserved concurrently with the development of minuscule, cursive forms of writing. At the same time, such scripts were being developed in other centres of scholarship throughout Europe; at Luxeuil in France, Bobbia in Italy, the Iberian peninsula of Spain and in the area ruled by the Merovingian kings of the Franks in northern Europe. Clearly, although local variations were numerous in the period of confusion following the collapse of the Roman Empire, the missionaries travelling between the many monastic centres provided a link in developing written forms.

At the end of the eighth century a general renaissance of European scholarship and culture was organized under the patronage of Charlemagne, king of the Franks (768–814) and subsequently Holy Roman Emperor, who governed a vast area of land stretching from Italy and Spain right across northern Europe. Charlemagne appointed Alcuin of York (735–804) master of the court school at Aachen, then, in 782, abbot of the monastery of St Martin at Tours. One of Alcuin's most important commissions was to revise and standardize the variations of minuscule scripts that had appeared. In doing so, he referred back to the original forms of Roman alphabets – square and Rustic capitals, uncials and half-uncials. In addition, he was directed to retrieve the original form of particular texts and eradicate all the corruptions and errors that had naturally arisen during many years of copying and writing from dictation, with all the attendant confusion that had been caused by the interpretations of individual scribes.

Alcuin's finest achievement was the development of a formal minuscule script for use as a standard book hand. This has become known as the Carolingian minuscule, after its instigator, Charlemagne. It was widely adopted throughout the Holy Roman Empire as the cultural reforms of Charlemagne were carried on by his successors. It also gained influence beyond the borders of that empire; for example, by the tenth century the Carolingian form was in general use in England, where, despite regional variations, the basic, considered form promoted by Alcuin was still preserved.

Another aspect of book production that was standardized during this time was the hierarchy of scripts, which was used to denote the different purpose and importance of information in the text. Major titles, for example, were written in Roman square capitals; the opening lines of text in uncials or a preface in half-uncials; the body of the text was written with the Carolingian minuscule, while amendments and notations might be added in Rustic capitals. The rich decoration of biblical texts, lavishly painted and gilded, also gave rise to elaborate capital and marginal letters and various forms of text ornaments. Monks employed in *scriptoria*, the writing rooms of the monasteries, worked long hours at their highly concentrated tasks. Different aspects of the writing and decoration would be carried out by different hands. The manuscripts sometimes contained colophons mentioning the names of the workers involved. In general, however, the work was undertaken for the glory of God and the dissemination of Christian ideals carried out by men who were humble in the service of their God and their archbishop, and any attempts to attract individual credit were not popular and actually discouraged.

The development of Carolingian minuscule was the most important landmark in the history of writing since the standardization of the Roman alphabet. From this point all the elements of modern writing were in place; modifications since that time have been essentially practical or fashionable, not basically structural.

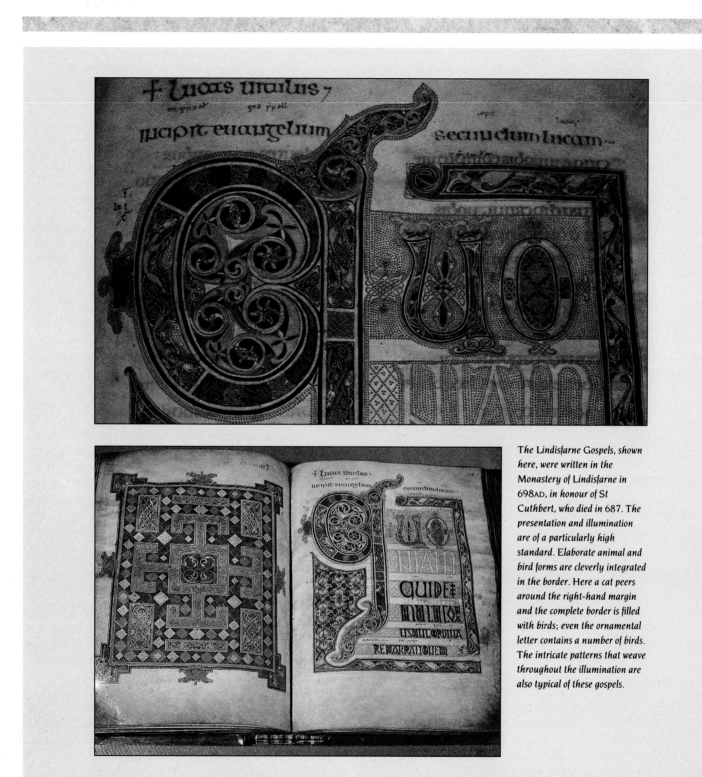

The Lindisfarne Gospels, shown here, were written in the Monastery of Lindisfarne in 698AD, in honour of St Cuthbert, who died in 687. The presentation and illumination are of a particularly high standard. Elaborate animal and bird forms are cleverly integrated in the border. Here a cat peers around the right-hand margin and the complete border is filled with birds; even the ornamental letter contains a number of birds. The intricate patterns that weave throughout the illumination are also typical of these gospels.

Gothic and Renaissance scripts

The Carolingian minuscule was the standard book hand of Europe in the ninth and tenth centuries and survived through to the twelfth century. In some places, however, definite changes in the style occurred quite early on. Tenth-century manuscripts written at the monastery of St Gall in Switzerland, for instance, began to show compression and angularity in the writing. Then, through the eleventh and twelfth centuries in Germany, France and England the style of minuscule writing became increasingly compressed and fractured; it formed an extremely dense, matted texture on the page. This particular form of Gothic lettering became known as Black Letter, which is a term that immediately suggests its heavyweight appearance and is thus an apt description.

The angularity of the minuscule script was mainly the result of writing quickly, with a slanted pen angle, which tends naturally to eliminate broad curves. The letterforms were compressed in width and became narrow and elongated; this allowed economy in the use of materials – more writing to the page – and, as the writing was more rapid, economy in the time spent by the scribe. There was a great need for this economy as the demand for written texts grew. In the late medieval period manuscripts were no longer just the privilege of the ruling classes and the Church; business affairs and secular education had begun to assume greater importance. There were administrative and legal matters to be dealt with, texts for schools and universities; the writings of philosophers and early scientists were in demand; books on subjects such as mathematics, astronomy and music were needed and, in the thirteenth and fourteenth

An English Grant of Arms (below), still bearing its original seal, displays 20 densely packed lines of an elegant, late Gothic cursive script, finely ornamented with a large illuminated capital and elaborately designed margin motifs which include the helmet and coat of arms. The grant was given in London in 1492. The script is extremely rich and even in pattern and texture. The slight slant of the writing and pointed ascenders mark it as a practical, rapid style, though sufficiently formal and ornamental for its purpose.

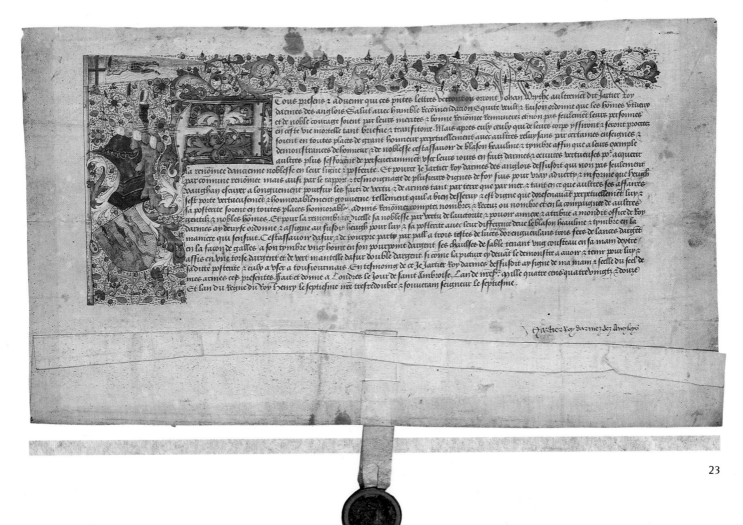

centuries, there was a growing literary tradition of poetry and story-telling. Professional scribes were no longer necessarily court employees or monks and the business of making books flourished.

Northern styles of Gothic Black Letter are known as Textura, in reference to the woven appearance of the page of text. Many different formal and informal styles of Gothic script emerged during the thirteenth and fourteenth centuries. In the later period the writing became mechanically even and rigid; two of the main formal variations were *textus prescissus*, with the vertical stems of the letters standing flat upon the writing line, and *textus quadratus*, which has the characteristic lozenge-shaped feet crossing the base of the stems. The *quadrata* style is particularly familiar because it became the model of printers' types in northern Europe. In this way it gained wider circulation, especially through the Bible, which was the first printed book of the Gutenberg Press, established in 1450. A number of cursive Gothic hands were also developed, characteristically angular and pointed with exaggerated ascenders. This general style was termed *littera bastarda*, to indicate that it was not a true script but a mongrelized version of the formal script.

Gothic was a term applied to the products of the late medieval period by the Renaissance scholars, who thought the cultural style of that period so outrageous that they named it after the barbarian Goths; like several other art historical terms, it was originally intended as an insult. The development of minuscule in Italy during that period also tended towards compression and angular forms, but it never took on the rigid vertical stress typical of northern European forms. In Italy the minuscule retained a more rounded character and was known as Rotunda, also identified as *littera moderna*. This style was used in handwritten and printed works until the late Renaissance period.

In fifteenth-century Italy new styles of writing were developed, which became known as Humanist scripts, because they were associated with scholarship and science. Around 1400 the Florentine scholar and scribe Poggio Bacciolini

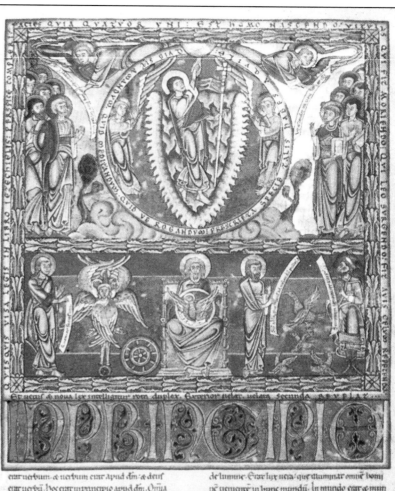

(1380–1459) returned to the original form of Carolingian minuscule as the source of a new book hand, an alternative to the Rotunda script. This was termed *littera antiqua* in acknowledgement of its origins, which were older than those of the *moderna*. Also in the early fifteenth century, the scribe Niccolo Niccoli (1363–1437) derived an angular, cursive hand from the

It is quite rare to find such a large script in a thirteenth-century manuscript (above). There is a tendency toward the Gothic hand with compression of the letters and very regular forms. The piece shows a high standard of gilded work and illumination.

informal Gothic cursive. This was the basis of italic script. Both men returned to classical Roman forms for their capital letters, and Niccoli's were given a slight slant, in keeping with the tilted stress he also used for his minuscule script.

These revised scripts influenced writing across the whole of Italy and became standard hands for the copying of classical texts. In addition, the papal scribes responsible for issuing the papal bulls and briefs from the Roman Chancery had resisted the peculiarities of Gothic script and developed their own cursive hand with flourished ascenders and descenders – the *cancellaresca* or chancery script.

The Subiaco Press, set up near Rome in 1465, took Humanist scripts as the model for type forms. Printing spread rapidly in Europe in the second half of the fifteenth century, but there remained a demand for handwritten manuscripts. The Chancery scribes were generally involved in producing single or limited numbers of copies so their work was not usurped by printing. Other scribes rose to the challenge of printing and it became a point of pride to produce the finest examples of their scripts, as long as handwritten books retained a certain prestige. Nevertheless, many lesser scribes came to the blunt realization that their days were numbered.

Paradoxically, printing was actually beneficial to various enterprising scribes; the age of the *scriptorium* was past, but people still had to write by hand and still took an interest in the proper forms of scripts. In 1522 the Venetian Ludovico degli' Arrighi published a printed book of writing samples, the *Operina*, for instruction in the *cancellaresca* style. In 1523 he followed this with a manual of several scripts including cursive Black Letter, Roman and italic forms. The printed copy-book became fashionable and several writing masters took up the idea, not only in Italy but in Germany, France, Spain and England. In this way the Humanist scripts spread out across Europe. The chancery hand, for example, was favoured in Tudor Engand and was actually adopted by Elizabeth I (1533–1603).

Handwriting and printing

As printing replaced the task of copying standard texts, the status and purpose of a scribe's skill declined rapidly. Writing became a day-to-day affair, no longer a specialized art or craft. Scribes turned to teaching the art of writing or copying business documents; in association with the tedium of the schoolroom or the sharp

In the fourteenth-century St Denis missal (below), the late Gothic script is executed in red and black and heavily decorated with pictures and motifs, given additional brilliance by the use of raised gold.

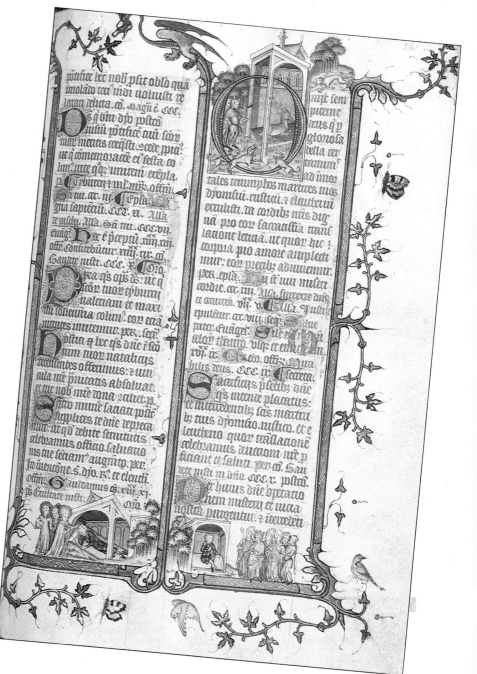

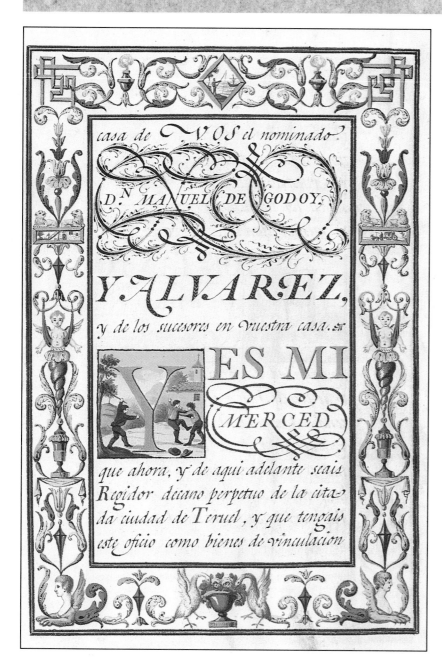

casa de VOS el nominado

DN MANUEL DE GODOY,

Y ALVAREZ,

y de los sucesores en vuestra casa.

Y ES MI MERCED

que ahora, y de aqui adelante seais
Regidor decano perpetuo de la cita-
da ciudad de Teruel, y que tengais
este oficio como bienes de vinculacion

An unknown Spanish scribe of the early nineteenth century was responsible for this bright and vigorous document, written in a fine italic script which refers back to earlier styles. Even such a late work follows the established traditions of calligraphy: black text highlighted with red, linear and painted ornament enriched with gold, and a large initial capital enlivened by a small narrative scene.

practice of lawyers and moneylenders, they lost all prestige. The writing masters, who published work and tried to attract individual patrons, were conscious of their precarious position and became fierce in their rivalry. They concentrated on developing ever more elaborate and eye-catching forms, as self-advertisement. The pure functionalism of medieval and Renaissance scripts became obscured in the extraordinary flourishings of the copy-book styles.

Arrighi's first book had been cut on wood blocks, which was a rather crude and risky technique for reproducing the fine detail of a script and the essence of pen-made forms. Later in the sixteenth century the technique of copperplate engraving became available; this was a delicate, linear style that could reproduce the finest flourishes of the pen more efficiently than it could imitate the broad strokes of a flat-edged nib.

One of the first writing masters to take advantage of copperplate engraving was the Milanese scribe Gianfrancesco Cresci. In 1560 he published a book, the E*ssemplare*, showing a flourished italic *bastarda* style, originally written with a narrow, round-point pen. This marked a definite break with previous writing traditions. The new styles were developed on the basis of a pointed pen, which was made to produce a variation in stroke by pressure, rather than by the effect of its natural shape. The flowing, looped and elaborated forms of script were written without lifting the pen. The basic form of such writing was, in fact, more speedy and practical, but the ornamentation was soon developed to excess in the search for novelty.

In the seventeenth century these decorative scripts became standard. The slow, intricate process of copperplate engraving, which involved copying a tracing from the original manuscript on to the plates, reduced the individuality of handwritten models. Ironically, the procedure had been reversed, so that those using the engraved copy-books were also forced to use pointed pens to imitate the model alphabets. In Germany the Gothic book script survived in everyday use, but copper-

plate styles were introduced to northern Europe. In England, France and Italy the italic *bastarda* took root and was propagated by the writing masters' elaborate publications. English penmanship was highly influential. Edward Cocker's *The Pen's Transcendencie*, published in 1657, and George Bickham's *The Universal Penman*, published serially between 1733 and 1741, were the standard works of their time. Bickham's opus contained 212 plates and represented the work of 25 different scribes.

These styles of penmanship continued through the eighteenth century and into the nineteenth. Copperplate hands were also taken to America by colonists and a London writing master, Joseph Carstairs had considerable success there in 1830, when his handwriting book was published advocating a technique using the whole arm, rather than the hand and fingers, to control the flow of the pen. Carstairs was also influential in England with this style. There were more modest variations of copperplate hands used in everyday business affairs, but in general the fine lines and looping ascenders of the formal scripts set the tone. The spread of literacy also had the effect of disseminating the debased scripts more widely.

During the nineteenth century metal pens came into general use; it is notable from

These samples are typical of the elaborate hands developed by the writing masters to show off their virtuosity with the pen. The earliest here is an italic script (above right) from examples published in Italy by Francesco Moro between 1560 and 1570. A fluid copperplate style, with convoluted joining strokes and flourishes (above) is a line engraving from A Tutor to Penmanship *assembled by John Ayres and published in 1698. A style similarly influenced by the technique of engraving is seen in the finely wrought initial letters from* Natural Writing, *produced by George Shelley in 1709 (below right). These items span more than a century but in each generation, as copy-books became more and more popular, there was fierce and public competition between contemporary masters.*

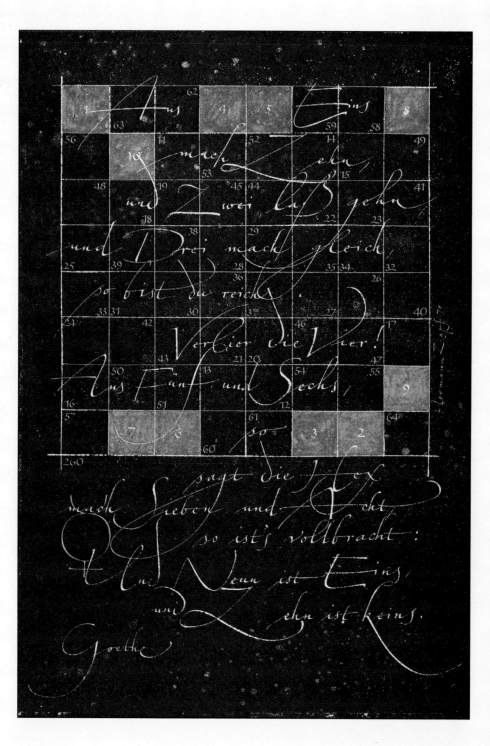

The influential German calligrapher and typographer Herman Zapf is well-known for the design of typefaces, notably Melior, Palatino and Optima. This experimental calligraphy is part of a series.

GEDICHTE VON HESSE

JOTT
gibt uns die Kraft
die Lasten des Lebens
zu tragen Wenn wir
in der Dunkelheit stehen,
ist er ein Licht auf unseren
Wegen.

MARTIN LUTHER KING

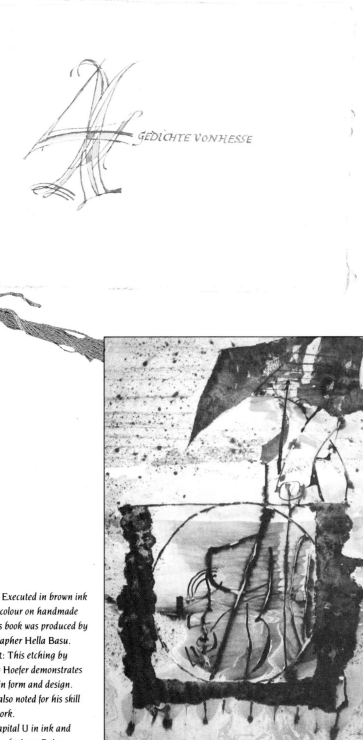

Top left: *Executed in brown ink and watercolour on handmade paper, this book was produced by the calligrapher Hella Basu.*
Top right: *This etching by Karlgeorg Hoefer demonstrates liveliness in form and design. Hoefer is also noted for his skill in brushwork.*
Right: *Capital U in ink and watercolour by Imre Reiner.*

manufacturers' advertisements that pointed nibs were the usual form. The mass production of text – books, broadsheets and pamphlets – was all accomplished by printing from metal typefaces. Another development was the introduction of lithography for colour printing of ornament and illustration. Highly decorated and illustrated books became popular, reviving interest in the forms of medieval illuminated manuscripts.

Essentially, then, the earlier traditions of European penmanship had been lost and the production of books and manuscripts was heavily dependent upon the relatively recent styles of elaborated ornament, many of which were entirely gratuitous and often recognized by some of the writing masters themselves as being of poor taste and construction. In the late nineteenth century the time was ripe for a revival of the pure penmanship of the medieval era and this was instigated in England by the work of William Morris and followed through by Edward Johnston, both of whom took the trouble to study the early manuscripts so that they might rediscover the proper techniques of their design and execution.

Materials and Equipment

Pens

There is a tremendous range of materials and implements available to the calligrapher. The craft is currently experiencing a revival and many companies are entering this market for the first time, especially in the production of writing implements. The craft of calligraphy does not require a large outlay: the main requirements are pen, ink and paper, and the main ingredient is a willingness to learn. Don't rush out and buy any old pen.

There are two main types of steel-nibbed pens: the pen nib with reservoir and pen holder, which requires constant filling, and the fountain-type pen, which has a built-in reservoir. The latter relieves the student of the tedious task of constantly refilling the reservoir, using a paint brush or pipette which then requires washing out, before continuing to letter; full concentration is needed and so any distraction or encumbrance should be avoided.

Whichever type of pen is chosen always inform the supplier whether it is for a right- or left-handed person. There are special nibs for left-handed users where the end of the nib slopes top right to bottom left when viewed from the top. Whichever pen collection is chosen, there will be a variety of nib sizes available, although the size of, say, an italic fine nib may vary between manufacturers, whether for a fountain pen or nib holder.

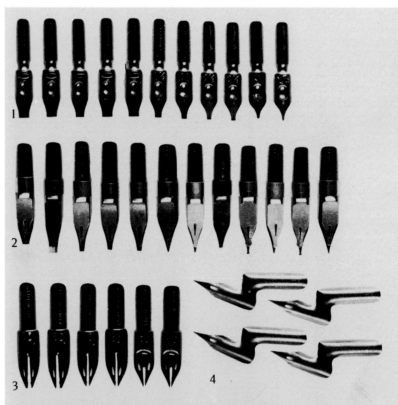

The range of nibs for metal pens is very extensive. Round-hand pens (1) are very versatile writing tools. They are able to produce a great variety of styles from italic to uncials. Assorted drawing pens (2) are also available with fine nibs from the flexible to the very rigid. Their various uses include sketching, lettering and cartography. The scroll pens (3) produce very individual writing. The double point on the nib draws two lines to give a shadow effect. The copperplate nibs have a very distinctive shape (4).

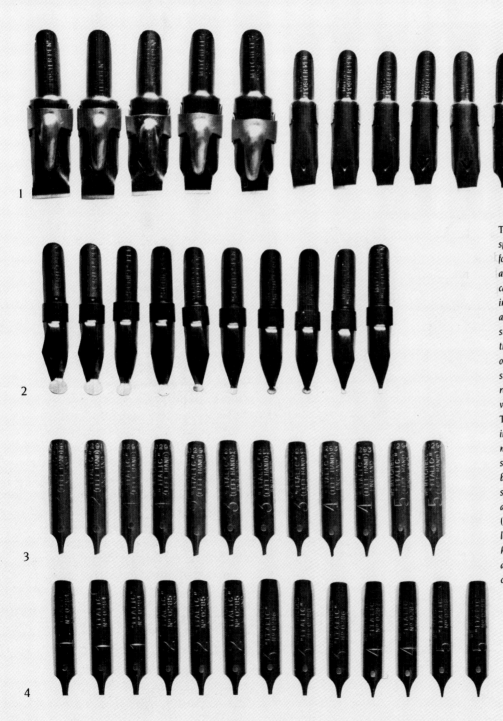

There are nibs that are designed specifically, for the large writing found in posters, for example, and for this reason they are called poster pens (1). They include the widest nibs available and can produce work with striking contrasts between the thick and thin strokes. At the other end of the scale, the plain-stroke script pen (2) has a rounded tip that makes no variation between the strokes. These are generally used for informal work. Italic nibs are manufactured in a large range of shapes from the extra fine to the broad. The intrinsic square shape of the nib is cut straight across for right-handed scribes (4) and obliquely to the left for left-handed people (3). The italic hand is one of the least formal and most popular of the calligraphic styles.

a squeeze-fill reservoir so that colour can be changed quite easily.

Don't be afraid to ask the local art shop or stationers to show their entire range. The larger suppliers often have demonstration pens that can be tested before finally making a decision to purchase.

PEN HOLDERS AND INKS
Once the student has gained confidence and experience with a pen, a pen holder and range of nibs is the next addition to any calligrapher's equipment. The range available is vast, including round-hand, script, poster, scroll and special-effect nibs. These items are sold separately or can often be bought on a display card which contains pen holder, reservoir and set of nibs. If a student does decide to purchase this type of pen he will need to remove the film of lacquer with which the nibs are coated to avoid deterioration. This can be done either by passing the nib through a flame briefly or by gently scraping the surface.

THE FOUNTAIN PEN
The modern fountain pen is the result of much effort to perfect a pen small enough to be conveniently carried and fitted with a reservoir large enough to provide a continuous supply of ink to the nib. The first description of a fountain pen was included in a French treatise on mathematical instruments of 1723, but a satisfactory design suitable for production in quantity was not achieved until the second half of the nineteenth century. This followed many experiments with methods of filling the pen and controlling ink flow to the nib.

Since that time little has changed in the basic design of the fountain pen. Recent developments include the use of ink cartridges as an alternative to a refillable reservoir and the incorporation of interchangeable nib units. Fountain pens are more specifically tools for handwriting than for formal calligraphy, suited to small-scale, cursive styles of writing. However, most pen manufacturers now include a calligraphy pen in their range of products, usually equipped with units that have edged

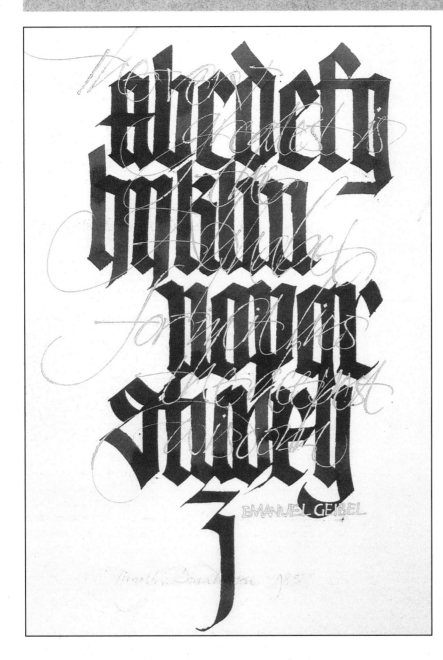

Gothic black letter, elongated and compressed, is the basis of this style (above), the heavy forms cleverly overlaid with a spidery script executed in shimmering blue-grey, an ambitious and highly successful combination of opposites.

FOUNTAIN-TYPE PENS
There are various calligraphic pens on the market. Some are purchased as an integral unit (that is, a complete pen); others are bought as a set and include a barrel, reservoir and a set of interchangeable nib units. Avoid the cartridge refill as it limits the colour of ink that can be used. It is better to buy a pen which has

nibs in small, medium and large sizes. The advantage of these pens in the practice of pen-made letterforms is the continuous flow of ink; the main disadvantage is that even the largest fountain pen nib is relatively small, in comparison with the range of metal pens available.

FIBRE-TIP PENS

Fibre-tip pens are now made with broad, chisel-shaped tips, especially designed for calligraphers. Like fountain pens, they are limited in scale, generally sold singly or as a set including broad, medium and fine tips, and with the advantage of a continuous flow of ink. A fibre-tip pen cannot remain as accurate and consistent as a metal pen, because the tip is more vulnerable to wear and tear; but for practising pen strokes or preparing rough layouts they form a useful addition to the calligrapher's collection of tools.

Felt-tip markers are also available with squared or pointed tips, but they are softer and more likely to lose shape than the fibre-tips. Some felt-tip pens are filled with a spirit-based ink that spreads on the page. They can be used for practice in drawing out the skeleton forms of letters, since they give a thicker line than a pencil.

Pencils and drawing aids

Pencils used for ruling the writing sheet should be fine and relatively hard. In early vellum manuscripts lines were ruled with a metal or bone stylus, but these were replaced by a sliver of lead, fixed in a holder. Modern pencils are made in a wide range of hard and soft grades. For ruling on paper H or HB pencils are recommended, since these give a sharp line but, used lightly, can be erased with no difficulty. Ruling on vellum should show a minimal mark; a very hard pencil, 6H or 7H, makes a fine, light line.

Double pencils can be a useful tool when learning to draw out the construction of letter-

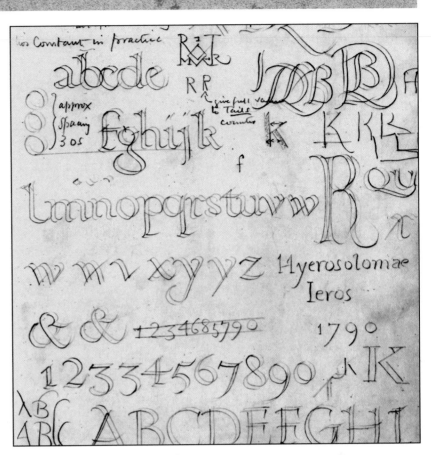

forms. Two HB pencils tied or bound together with tape form a twin-point that produces the same effect as a stroke from an edged pen, but in outline form. This demonstrates graphically how thick and thin contrasts are formed naturally by the angle of the writing edge on the paper.

Carpenters' pencils are broad and flat; the lead can be sharpened and honed on fine sandpaper to a clean chisel edge, which imitates the action of a broad, square pen.

An important accessory for the calligrapher is a sturdy and accurate ruler. A wooden rule edged with metal is a good choice, preferably 2ft (60cm) in length. As well as measuring and drawing ruled lines the metal edge of the rule can be used to guide a knife when cutting paper or vellum. A few other drawing aids are essential to the calligrapher, such as a T square and a clean, soft eraser.

Double pencils can be used to illustrate more clearly the effect of different nib widths on the pen strokes. Johnston used the double pencils in this page of writing taken from a demonstration notebook made for Dorothy Bishop (now Mahoney). The pencils have been used to make upper- and lower-case letters in Johnston's Foundational hand. The additional note in the top left-hand corner indicates the ratio of nib widths to letter height. Below this, the three lower-case o's illustrate the space required between lines of writing. The note in the centre relates to the importance of the tail in the capital R.

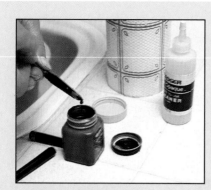

Emptying the ink from the pen.

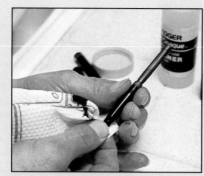

Removing the nib and ink feeder from its housing.

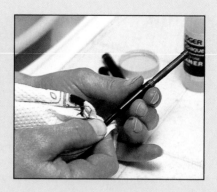

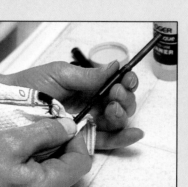

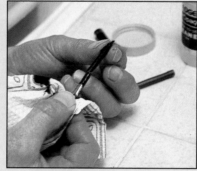

Separating the nib from the ink feeder.

Washing out the housing and ink holder, or reservoir, in water.

General maintenance

For some, pens are not the easiest of implements to work with: they blot, dry up in the midst of a stroke or even refuse to write at all. However many of the complaints levelled at pens are due to poor maintenance. Just like any other tool, they need a certain amount of care and attention if they are to perform properly.

Professional calligraphers recommend that a fountain-type pen always be emptied of ink after use, unless it is to be re-used in a short space of time. Ink soon dries both on the nib and in the ink-feed section, rendering the implement useless. Time and effort can be saved by emptying the reservoir into the ink bottle and flushing the pen with lukewarm water which contains a drop of washing-up liquid. This simple measure is ideal for water-based inks and will keep the pen in good condition.

Occasionally it is necessary to strip down the whole nib unit and clean it with soapy water and an old toothbrush or nailbrush. Most manufacturers would be horrified to think that such an act was necessary to clean their pens, but when changes of colour are required from, say, black to red, merely flushing the pen is insufficient to remove all the black ink, and the red or lighter colour will be tainted if the pen is not completely clean. If a pen has been left with ink inside for a period of time, without use, it will require stripping down in the same manner. A pipe cleaner is ideal for removing ink from inside the squeeze-type

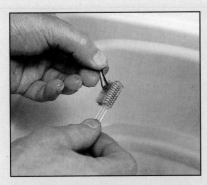

Using a toothbrush soaked in cleaning fluid to clean the parts.

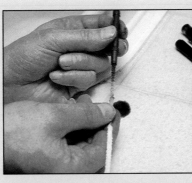

Using a pipe cleaner soaked in fluid to remove all the ink from inside the ink holder or reservoir.

Aligning the nib and ink feeder before reassembling the pen.

reservoirs, but make sure that its wire centre does not puncture the plastic.

There are now many different waterproof inks available for use in fountain-type pens. The colour range available is so vast that most students cannot wait to try them out. The snag about waterproof inks is that, once the pen is left for a short time, a waterproof ink will dry up and be difficult to remove with a water-based solution.

There is a cleaner available which is primarily used by airbrush artists for removing the colour from the airbrush. It is ideal for a thorough strip-down operation. The fluid has no harmful effect on the pen and removes even the hardened ink, but it is always best to ask the supplier if it is safe to use on plastics.

If the ink stops in the middle of a stroke, remove the barrel and squeeze or turn the reservoir, depending on the type of pen, until the ink reaches the nib. Make sure you have a paper towel at hand to prevent a disaster.

A pen that is drying or missing during writing may have insufficient ink, or the split in the nib may have become widened by pressure. To solve this problem either fill the pen or reduce the split in the nib by squeezing both sides together. Also check that the nib and ink duct are free from particles picked up from the paper surface. Ink will not take to a greasy surface. To remove such marks a good proprietary lighter fuel may be used. Test a sample of the same paper to ensure that the petrol does not leave a stain.

Rulers and set squares (triangles) should be cleaned only with warm soapy water. Abrasive cleaners will damage the plastic and remove the calibrations.

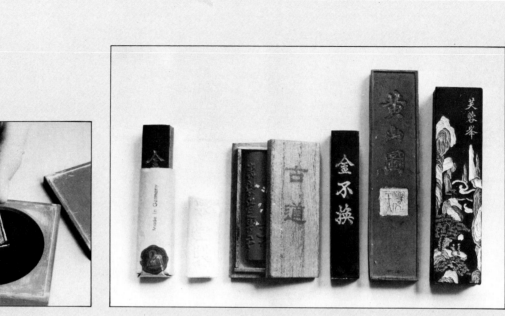

Chinese stick ink is popular with scribes because it does not clog the pen. The ink is literally sold in sticks (above right) in varying colours, which have to be rubbed down with distilled water. Ink stones are used for this process. Distilled water is poured into the central well of the *rubbing stone and the ink stick pushed back and forth in the water (above left) against the abrasive surface of the stone. Stick ink should never be stored when it is still wet as this will cause it to flake. The ink stone should always be washed after use.*

Inks

A number of recipes for ink may be found among old treatises on writing and, together with the materials used by earlier scribes, it may be seen how effectively they have stood the test of time. The most common recipes were for carbon inks, using a pigment such as lamp black suspended in a mixture of gum and water. These have retained their blackness over the years. The attractive brown tone of the writing in some manuscripts is not due to original use of sepia ink; it is the result of the chemical change in an ink that was originally made from iron salt and oak gall, that has gradually worked its way into the surface and lightened with age.

The commercial sale of prepared inks became common in the eighteenth century. As greater efforts were made to perfect metal pens, it was found that inks suitable for quills often had a corrosive effect on metal nibs. Some nineteenth-century pen manufacturers began to produce their own inks to suit their particular pens. The introduction of aniline dyes in 1856, used for colouring paints and inks, to some extent relieved the problems since they were found less corrosive than pigments formerly used.

Modern scribes have a number of high-quality brand-name inks to choose from, although experiments based on old-fashioned recipes are still pursued and sometimes result in special qualities that are sympathetic to individual styles. It is also interesting to try out different types of prepared inks, as the best combination of technique and materials is unique to every scribe.

The favoured ink of many modern scribes, from Edward Johnston's time to the present day, is Chinese stick ink. Stick ink is rubbed down with water so the scribe can control the density of colour and texture. A small, sloping block with raised sides and a slightly abrasive surface is supplied, which can be used both as a rubbing surface and as a container. The ink is rubbed down in small quantities as needed, and it is important to keep the stick dry when it is not in use. Distilled water produces the purest dilution of ink. If none is available, ordinary tap water may be used as an alternative, provided it is boiled and allowed to cool. The texture of the ink can be varied from one mixing to another. To make it possible to match the consistency, a fixed measure of water and amount of time for rubbing down the stick allows the process to be quite accurately repeated. Johnston also recommended the use of stick ink because small amounts of mixing colour or gum could be added during the process to obtain a precise effect of colour and texture.

There are many inks available to the student, and choice is made difficult by this fact. The main property an ink should have is that it should flow easily and not clog the pen. Non-waterproof ink flows marginally better than waterproof inks and watercolours. The medium should not spread on the writing surface. Unwanted feathering can be attributed either to the paper or to the ink, and the student should experiment with both to confirm compatibility.

Density of colour is important in finished work, and there are inks available which are specifically stated as being calligraphic inks. These are suitable for use in fountain-type pens. There are also inks that are referred to as 'artist colour', some of which are waterproof; many need a cleaning fluid to clean or flush the pen through after use. (Check with the stockist that such a cleaning agent will have no harmful effects.) The range of colours is wide, and most of these types of ink are miscible, giving an even wider range.

Calligraphers often use watercolour paint for embellishment. This is satisfactory for a pen and holder but not for a fountain pen. Instead of watercolour, pens can be filled with artists' retouching dye, which is translucent and the colour is very pure and water soluble. Ink and watercolours vary in light fastness; so check the label for the degree of permanence.

Some bottles have a pipette incorporated in the cap. This is useful for charging the reservoirs in pen holders and saves loading with a brush.

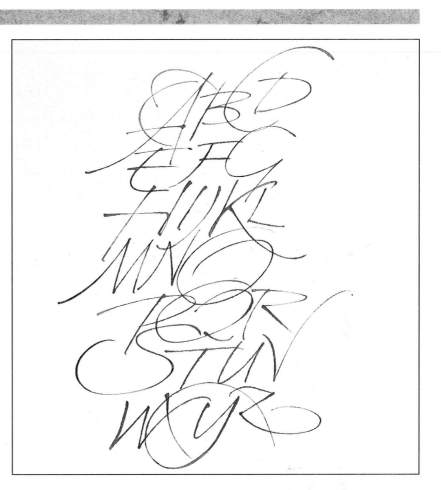

A rhythmic and elegant capital letter alphabet by modern scribe Robert Boyajian, is enlivened by the use of subtly contrasting coloured inks applied from a fine ruling pen.

Papers

The variety of papers available for writing, drawing and printing is a relatively recent development. Early scribes used vellum or parchment not so much from preference as from necessity. Paper manufacture was not fully introduced in western Europe until the fourteenth century. Ironically, in the context of calligraphy, it was printing that stimulated the paper industry, since vellum was not suited to book production by mechanical methods. The disadvantage of paper in those early years, and to some extent still today, was that it was fragile and likely to deteriorate rapidly. This is one reason why the tradition of using vellum for specially prestigious documents still survives.

The word 'paper' derives from papyrus, the plant used by the Egyptians to form a writing surface. A sheet of papyrus was made by hammering together vertically and horizontally positioned strips of the fibrous stem of the plant. Papers are still made from vegetable fibres, which are pulped, poured into flat sheets, drained and pressed. Up to the nineteenth century paper was made by hand, limiting the size of a sheet to the breadth of a paper-making tray that could be handled by one or two men. With the industrial revolution machines were developed that produced paper mechanically, turning it out on long rolls, known as webs. Both these processes are still used, but it is becoming more difficult to obtain handmade papers. The quality and variety of machine-made papers, however, is continually expanding.

The choice of paper is so dependent upon the touch of the calligrapher, the tone and texture required for the work, the size and weight of the lettering and so forth, that it is not possible to list suitable papers by name. There are, however, a few general rules that can be observed as the basis for personal experiment.

Cheaper-grade papers are generally made from wood pulp. They are adequate for ordinary purposes, but papers with a rag base, pulped from cotton, linen or hemp, are the most durable and less likely to tear or buckle. The heavier fibres also suffer less where erasures are made. Papers are produced in different weights, with surfaces graded as either hot-pressed, 'not' or cold-pressed, or rough. Hot-pressed papers have smooth, close-grained surfaces and are the most suitable for formal calligraphy. Rough and not papers are somewhat more absorbent and loose-textured. Unsized paper is too porous, allowing ink to spread into the fibres, but a paper too heavily sized will resist the medium. The pen strokes of calligraphy are lightly made; any surface that drags on the pen or is picked by the nib is unsuitable. Highly glazed or coated papers are too smooth and resistant for pen work.

For the beginner, a draughtsman's or designer's layout pad is ideal for roughing out ideas and preliminary penwork. Pads come in various sizes, finishes and weights. Initially, choose a paper that is not too opaque and make sure, when the paper is placed over the sample alphabets in this book, that you can still see the letterforms through it.

There are typo pads specifically made for designers' layouts. This type of pad is ideal, because it is used for tracing letters in studios when laying out work. It has a slightly milky appearance and is not as transparent as tracing paper.

Bond paper, smooth and white, is sold by stationers in a less varied size range, but A4 or foolscap are adequate for calligraphic practice. Writing pads and papers intended for correspondence are also useful grounds and are available in a wide range of colours and surface finishes, smooth and antiqued. The matt side of brown wrapping paper or a roll of unwaxed shelf paper provide quantity and economy for rough work. For outdoor work such as posters, special papers that weather well can be used, but do not forget to use a waterproof ink.

For finished work a good quality cartridge paper can be perfectly suitable. Some types have a warm, creamy tone which may be preferred to a stark, cold white. Close-grained

Ingres paper for finished work, available in pads or single sheets.

On the first
day of
Christmas
my true love

sent to me,
A partridge
in a pear
tree,

*Careful choice of paper may
enhance the design and increase
the effect of the calligraphy.*

*Design by Donald Jackson.
These letters were drawn on to
vellum with a reed pen. The reed
tip had a centre notch removed
to give the parallel-line effect.
The colour was added separately
afterwards. The gold leaf is being
applied with a haematite
burnisher.*

effects in basic or formal calligraphy. For those wishing to develop a looser style, chance combinations of pen, ink and paper may be a large part of the pleasure. Coarse-grained papers will give a broken effect to the pen strokes; Japanese calligraphy, particularly, exploits the qualities of different paper textures. A surface with a strong or variegated colour will increase the density of a written page. With experience it becomes possible to control such features to some degree, while exploiting their particular contribution to the work as a whole.

VELLUM

Vellum is the writing surface traditionally preferred by scribes for many centuries. It has a velvety nap and slightly springy surface that is ideal for the sensitivity of a quill. Vellum is prepared from calfskins (and sometimes also from goatskins) in a skilful and lengthy process. The procedure cannot be fully mechanized and has changed little. As each skin is different in texture and weight, the preparation processes and finishing must be tailored to the quality of the skin and the purpose for which the vellum is required.

Fresh skins are first soaked in a lime paddle for 10 to 15 days to clean away salt and break down the fibres. Each skin is then individually passed through a machine with three large rollers, one of which is equipped with blunted knife blades, to scrape off the fur. (Previously this was done by hand using a double-handled knife.) After soaking in lime for another week, a skin is passed through a similar machine, with well-sharpened blades, to scrape off fat and flesh from the underside, then returned to the lime paddle for a further two weeks.

The cleaned skin is stretched on a wooden frame, using string attached to pegs, which can be turned to pull the skin taut. In fine weather it can dry naturally, but heat-drying is usually employed. To prepare the writing surface, a craftsman shaves each skin with a semicircular blade, taking account of its individual thickness and any weak areas. This removes the grain and smooths the surface, which is finally treated with pumice.

hand- or machine-made papers with a hot-pressed surface are heavier and more resistant to damage. As with vellum, it is advisable to obtain offcuts or an extra sheet of a particular type of paper for trial purposes. Handmade papers are generally preferred for important pieces of work, but they are relatively expensive and may be more difficult to obtain. Because of the process of manufacture, they are of limited size and may not be perfectly square at the corners. Allowance should be made for this in ruling the page. They have deckle edges and should be torn rather than cut if the dimensions are altered; sometimes it is preferable to trim all the sides cleanly. Some machine-made rag papers are prepared in imitation of handmade papers, while others have their own distinct character and quality. The tone of paper may vary from one sheet or batch to another. In work requiring matched sheets, it is advisable to buy slightly more than the exact quantity required.

These guidelines are laid down as a basis for buying papers of reliable quality for controlled

For fine writing, vellum is finished to a light, even tone, which may be brownish or mottled, depending both on the finishing processes used and also on the original fur and skin colour. The calligrapher can choose which type of vellum to use according to personal preferences and the nature of the job in hand. A light variation of warm tones in the vellum can add richness to the finished work. Coloured vellums sprayed with dye are available, as are coarser, more grainy surfaces. The tougher vellums are really intended for utilization in bookbinding.

The manufacturer prepares the vellum to a good finish, but practised scribes will prefer to give the surface further preparation before writing. Vellum is sensitive to atmosphere and can absorb too much moisture or dry out if it is kept in the wrong conditions. If stored over a long period, residual grease in the skin will work its way to the surface. Powdered pumice or powdered cuttlefish can be used to rub the skin lightly, but these materials are abrasive and may make the surface more porous. A light dusting of gum sandarac counters this effect, but if it is too liberally applied the surface will resist ink. Gum should not be used before gilding as it may hold the gold leaf where it is not wanted.

The hairside of vellum is tougher than the skinside. Any abrasive treatment should follow the grain of the skin and be applied more gently to the skinside. If vellum is used in making a book, it is usual to match the pages hairside to hairside and skinside to skinside. For a broadsheet or flat text, the side used is a matter for the scribe's judgement.

Vellum is relatively expensive compared to most papers; the price corresponds to the size required and the maximum size obtained from any one skin is about 30 × 40in (70 × 100cm). Suppliers usually sell small offcuts, which can be used for testing the finish and trying out the feel of ink and pen on the surface. Corrections on vellum can be made by scraping the ink with a sharp blade, taking care not to cut into the surface. An eraser and pounce are used to clean up the alteration.

A stylus, made of metal or bone, was an important item in the scribe's equipment. In early manuscripts the writing lines were sometimes ruled with a fine sliver of lead, but a commonly preferred method was to prick the measurements on vellum with a sharp point and then score the back of the page between the marks with the rounded points of the stylus. This raised a line faintly on the upper side of the vellum and was not as obtrusive as a drawn rule.

PARCHMENT

Parchment is made from the inner layer of sheepskin by a process similar to vellum preparation. The sheepskin is limed and split. Flesh is removed from the inner layer and the skin is treated again with lime, then stretched, scraped and degreased. The stretched skin is dried, shaved and pounced to create a fine surface finish.

Parchment is different in character from vellum and is an alternative, not a substitute. Sheepskin is naturally oilier than calfskin and parchment has a tough, horny texture. Vellum is generally preferred, although in the past parchment has been used for books, because the split skins were thin and less bulky in quantity than vellum pages.

Brushes

It is actually possible to produce a brush-stroke effect with a very broad-nibbed pen. There is almost as much scope and skill involved with this tool as with the brush. Below, Arthur Baker, an American scribe, has produced a free-style, pen-drawn alphabet, where the heavy forms are legible mostly through familiarity. The texture of the writing surface is often visible when using such a broad nib, particularly where letters are formed quickly. The broken strokes on the ascenders and descenders demonstrate this.

There are three main purposes for which a calligrapher may need a selection of brushes. One is for feeding ink into the pen. A medium-sized, roundhair sable brush suits this function. The same type of brush can be used for applying size and colour in decoration. It is as well to have at least one fine and one medium for this purpose, and if colour plays an important role in the work, it is advisable to build up a good collection of different types of watercolour brushes.

A brush may replace the pen as the calligrapher's writing tool. This is the basis of eastern calligraphic traditions, but is less common in the west. There are many different kinds of oriental calligraphy brushes with hair and feather tips, whose uses are generally unfamiliar to those trained in the tradition of the pen. However, it is possible to acquire these brushes and to experiment with brush-drawn lettering.

The nearest equivalent to the shape of an edged pen is the flat-tipped sable brush, sold for use by watercolour artists. Roundhair brushes are also used for lettering. The characteristic changes from thick to thin strokes, natural to the pen, are softened by the flexibility of a brush. It tends to produce more evenly graded forms. A different type of lettering tradition is represented by sign-writers' brushes. These are fashioned with long, narrow, rounded hair tips; the finest are made by fitting the hairs to the shaft of a quill.

Brush-writing techniques, like those of the pen, must be learned through experience.

Paints and pigments

The colours of illuminated manuscripts were applied using pigments bound in gum or egg. Modern scribes will find artists' watercolours the most suitable medium for writing in colour and for painted decoration. Watercolours are pigments bound in gum arabic, with one or two additives to maintain flow and texture. They have a luminosity that other paints do not. They are available in tubes or pans and, for pen work, should be diluted to a milky consistency with high colour saturation so that the hues are not devalued. When watercolour is used for painting with a brush, it should be of a stiffer consistency because washes are difficult to control, especially on vellum.

Manufacturers are careful to develop as much permanence in their products as possible, but some pigments are naturally fugitive and will fade more or less quickly under long exposure to light. Artists' materials are marked with the degree of permanence, so it is possible to choose the most reliable colours.

Calligraphers who are interested in following traditional techniques can still mix their own colours, using gum arabic, egg yolk or glue size as a binder for powder pigments. Pure, finely ground pigments must be used and the richest hues can be extremely expensive, even when bought in minimum quantity. The pigment and medium can be mixed together in a small jar or ceramic palette with mixing wells. Distilled water should be used as the diluent to maintain the purity of the colours

Alan Wong, an oriental calligrapher, designed this motif for a greeting card (below left). The modern style Chinese characters were written with a brush. Brush lettering may be produced with a variety of tools (below). A bamboo stem makes a good brush, where the fibres at one end are broken up to provide a bristly tip (1). A duckdown feather provides a very soft-tipped brush (2). An alternative feather, which is popular with the oriental calligraphers, is the peacock feather (3). A hair tip is broad and soft, but fashioned into an extremely fine point (4). Such brushes give great variation in the brush strokes.

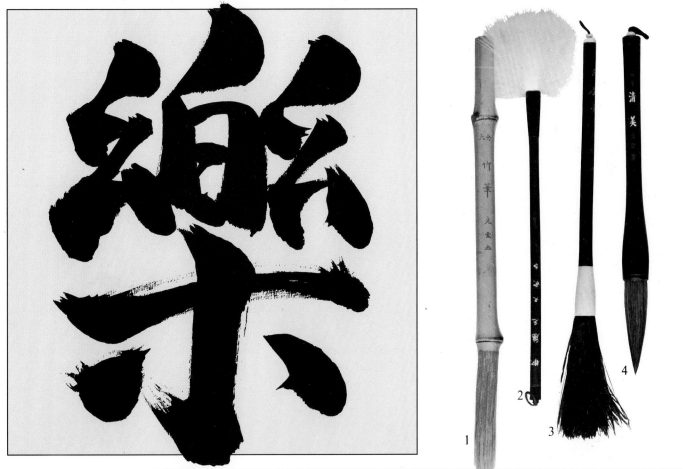

43

Technique

The angle of
the pen

It is the angle of the nib in relation to the direction of writing and stroke which gives the letterforms their characteristics. A style that is formed with the nib angle at 30° to the writing line will have a different visual appearance from that lettered at 45°. This is because it is the angle that determines the weight of each stroke and the stress of the round letters. Because the angle is maintained from letter to letter, with the exception of one or two strokes, a certain quality and rhythm is created throughout the letterforms.

Because the pen angle is 30°, a vertical stroke will only be as wide as the image the nib will make at that angle and not equivalent to the full nib width. In a round letterform, there is a point at which the whole of the nib width is used due to the pen travelling in a semicircle.

The maximum width of stroke – 'the stress' – will be exactly 90° to the thinnest stroke, which is fortunate for round letterforms because, if the nature of the tool used did not produce this automatically, round letterforms would appear thinner than vertical ones of the same weight.

Weight of stroke is determined by the angle of the pen and the direction of travel. Diagonal strokes will vary in weight depending on the direction of the stroke. Strokes made from top

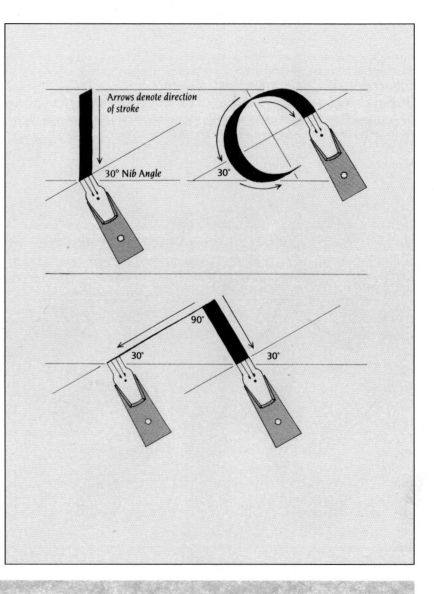

left to bottom right are more consistent than those formed top right to bottom left. Horizontal strokes are of a uniform width. These variations are acceptable in pen lettering and give the forms a natural, unforced appearance. The alphabet is constructed from common vertical, horizontal, diagonal and curved strokes.

To illustrate the effect of pen angle, Edward Johnston devised the idea of relating it to a clock face with the writing line running horizontally through the centre. When the pen is held in the position for straight pen writing, the thickest stroke runs from 12 to 6, the thinnest from 9 to 3. It can then be simply compared with slanted pen writing at an angle of 30°, when the thickest stroke follows a line through 11 and 5, the thin stroke lies between 8 and 2.

Continuing the image of the clock face, it is further seen that a line can be drawn between 10 and 4, but with the pen kept flat with the horizontal or at an angle of 30°. In the straight pen form, the stroke between 10 and 4 is relatively thin, since it falls closer to the thin stroke at 9 than the thick at 12. In the slanted pen writing, however, the line from 10 is closer to the thick stroke, so it remains relatively thick. Since it is initially quite difficult to maintain a constant pen angle whatever the direction of the stroke, experiment with the clock face construction is useful in demonstrating the basic principles of how the width of the strokes will change. When the contrasts between the effects of a flat pen and a 30° angle are understood, it is then only a logical extension of that principle to realize how a precisely similar shift of emphasis occurs at a 45° angle, or, in fact, at any point between 0° and 90°.

For a left-handed person, the natural position of the writing hand reverses all these directions and effectively operates from the other side of the clock face.

Letterforms within the alphabet have common likenesses and, although there are 26 characters, the strokes that are repeated within the capitals and lower-case are frequent. This repetition makes the task easier: once the basic strokes are mastered, the forming of individual letters is relatively simple.

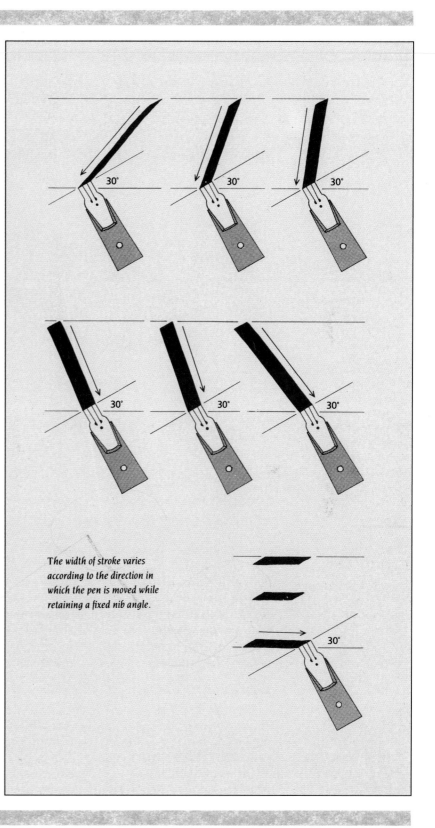

The width of stroke varies according to the direction in which the pen is moved while retaining a fixed nib angle.

Blackboard exercises provide an excellent opportunity to practise rhythm in writing. Using special chalk, square in section, to imitate the action of a pen nib, experiments can be made on a large scale, as these uncials show.

Practical penmanship

The physical activity involved in formal calligraphy is minimal, but concentration and a steady hand are absolute requirements. The first essential, then, is simply to ensure that the working position is comfortable. It has already been explained that there are good reasons for working against a slanted rather than a flat support. To this can be added that the calligrapher's posture should be erect rather than stooped, so a chair with a firm back support is important and the feet should also be well supported, either on the floor or on a sturdy bar of the chair.

The pen should not be under pressure; calligraphy requires a light touch but, at the same time, sufficient firmness to ensure fluid evenness in the strokes. Johnston explained that ideally the pen should 'glide' on the surface. The pen grip for calligraphy is not as tense as that used in handwriting, when speed and pressure are less controlled. In essence, the best way to hold the pen is in the most natural and comfortable position, usually supported by thumb and forefinger and with the shaft of the pen lying in the curve of the hand between them. To release tension and discourage the temptation to apply too much pressure, the fingers are more extended than in the grip used for handwriting; there is no need to clutch the pen. The pen is held at a shallow angle to the paper; the heel of the hand rests lightly on the paper guard. Very slight variations of pressure can assist in describing a pen letter – for example, an increase of pressure moving

into a curved stroke can be gradually decreased on coming out of the curve. However, a single pen stroke is a delicate movement and the increase of weight or tension is extremely subtle in such cases.

If the calligrapher fills the pen by simply dipping it into the ink bottle, it is difficult to control the amount of ink in the reservoir and the fluid may drip or flood on to the paper. The recommended method for charging the pen or quill with ink, and this must be done frequently, is to hold the pen in one hand with a brush in the other, and use the brush to feed ink directly into the reservoir of the pen. The pen should always be moved into contact with the brush for filling, and not vice versa. It is also important to prevent the ink from touching the upper surface of the nib. This method of using the brush may seem distracting to a

beginner who is trying to concentrate on the letterforms, but it soon becomes second nature. If the dipping method is found much easier, however, it can be used, but it is wise always to test the flow of ink on a piece of scrap paper before starting to write, to draw off any excess ink clinging to the nib. This should also be done when fine or lightweight lettering is being written, even if the pen is brush-filled, because an overloaded nib will inevitably destroy the crispness of the pen strokes.

The pen can be wiped clean with a rag whenever necessary and if ink dries on the nib, clogging the reservoir or the slit, the pen can be rinsed out carefully with water. But it should be wiped and dried after washing, to avoid any deterioration of the metal which, even on the most expensive types of pen, does tend to oxidize if left damp.

This seventeenth-century illustration shows the correct way to hold a quill pen to produce the writing style then in vogue. The nib of the quill was cut to a fine point to produce the thin flourishes which decorated the writing.

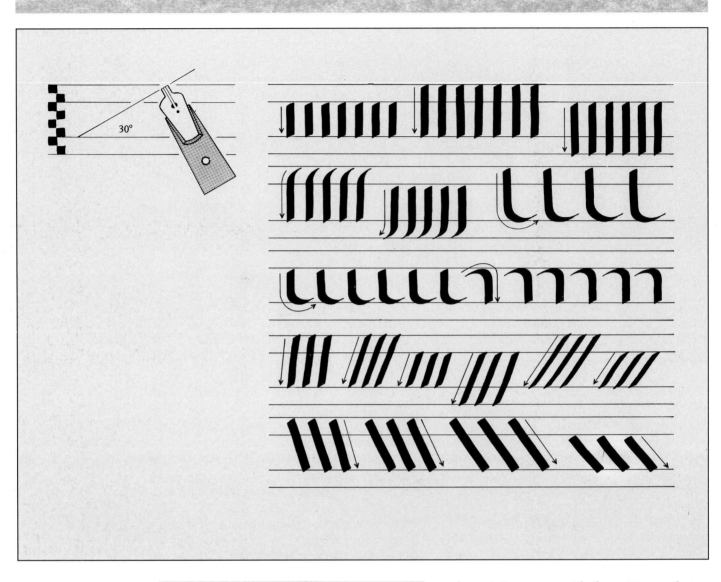

Forming strokes

Unlike handwriting, where the pen is lifted from the paper only occasionally between words or necessary breaks in form, calligraphic lettering dictates that the pen is lifted after each stroke. It is the combination of strokes which creates the letterforms.

The pen is nearly always used with a pulling action towards the letterer. Horizontal strokes are made from left to right. The nib should glide across the sheet with just enough pressure

to keep it in contact with the writing surface.

It is at this point that problems often face the newcomer to calligraphy. It is essential that the pen angle is maintained while producing the stroke, whatever direction is taken. This usually takes all of the student's concentration and can result in the nib not being in contact with the paper throughout the movement. This skipping will cause an uneven weight in the stroke, and the result will be patchy.

Control over the pen for small letters is with the fingers for the up-and-down movements, with the wrist being employed only slightly for

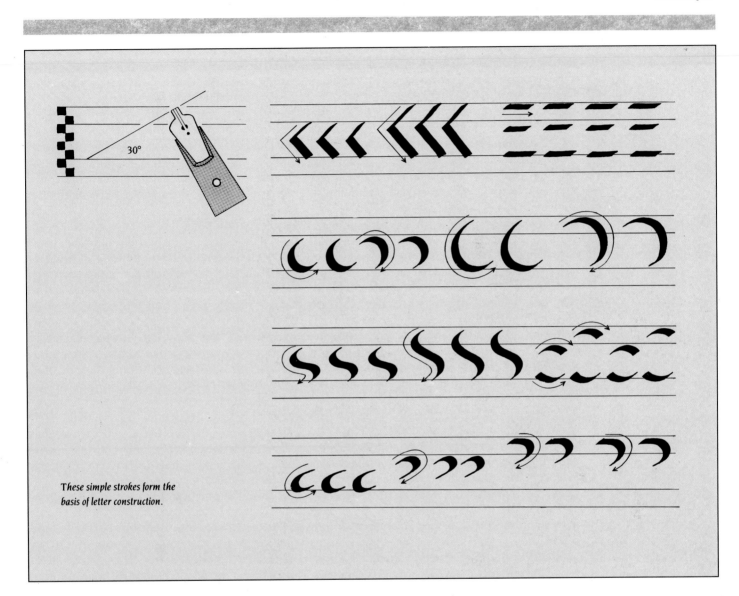

These simple strokes form the basis of letter construction.

rounded letters. When forming larger letters, say over ¾in (20mm), the movement is from the shoulder with the whole arm moving down the writing surface. The height of letter at which the transition from finger to arm movement is made is dependent upon the dexterity of the individual, and also relies on considerable practice.

The exercise requires mainly finger and wrist action with, perhaps, some of the longer, diagonal strokes needing arm movement. The third and little finger rest on the paper and help to support the pen holder.

BASIC LETTER STROKES

Begin by tracing over the forms given in the exercise on the previous page and above. To do this, a nib that is of the same size as that used here will be required. Take a nib and compare it with the nib and width of stroke marked at the side of the sample exercise. It will be beneficial if the size can be matched exactly, although a small variation will not matter at this stage. The main aim of the exercise is for the student to become familiar with the action of the pen and to develop a rhythm when forming the images.

It may be found useful to mark light pencil lines showing an angle of 30° at intervals on the writing line to provide a visual check on the angle of the nib. Since the position of the hand is most natural in writing slanted forms at this angle, it is the easiest way to gain confidence and familiarity with the motion of formal writing. To understand the pen angle and the thick to thin contrast of the stroke, the beginner may, at first, want to try out some simple pen strokes – vertical, curved, oblique. It is more valuable, however, to study the strokes used in a particular alphabet form and relate the pen practice immediately to the typical components of the letters. In addition, this breaks the habits of handwriting and implants familiarity with the number and order of strokes used in forming the different letters.

In keeping with the principle of allowing the pen to make smooth, unforced movements, each letter is composed of two or more strokes (except I and sometimes J). They are put together in accordance with general rules governing the direction of each stroke and its order in the sequence of construction. The logical sequence of strokes, and that most natural to the movement of the hand and pen, is to construct the letter from left to right and draw the strokes from top to bottom. Thus vertical and oblique strokes are described from the upper limit of the letter height down towards the writing line. This direction applies to all oblique strokes, whether they fall right or left of the vertical, or actually cross it diagonally.

Round letters are formed with arcs, again moving from top to bottom, starting at the narrowest upper point and finishing at the narrowest point at the case of the letter. For example, the O can be thought of as two symmetrical curves moving in opposite directions. In letters with partial curves, the number and sequence of strokes must be assessed in relation to the quantity of the full circle or ellipse that is included in the curve and how it is placed in the graduation between thick and thin.

Usually, the vertical stem of a letter is the first stroke. An exception to this rule occurs in lower-case letters a d and q, which have a bowl to the left of the stem. Here the bowl is formed first, constructed from partial curves, and the stem is added to the bowl. Letters that have no vertical stroke are formed in sequence from left to right, the four strokes of M and W, for example. In H and N the verticals are made first and the bar of H and diagonal of N inserted to join the two. Horizontal cross-strokes are made in the order top, bottom and centre; thus in E and F the central horizontal is the final stroke and T is formed with the stem first and then the bar.

The number, order and direction of strokes follows a logical pattern, bearing in mind the basic character of the letter and the pen angle.

It is difficult at first to feel quite natural about the frequent pen lifts made in formal calligraphy. There may be a tendency to break the stroke rather abruptly, leaving a ragged tip, or to draw out the stroke too far. One method to practise is lifting and turning the pen at the end of a narrowing curve; this can be done in one smooth movement where the nib is allowed to glide up and away from the paper, lifting the leading tip of the nib edge as it comes out of the stroke. Dexterity is an important part of calligraphy and, in time, the rhythm of different strokes should become instinctive.

For initial practice of strokes and letterforms, it is only necessary to rule horizontal lines on the paper, allowing plenty of space between the lines for the height of the letters and ascenders and descenders, if any. Capitals can be spaced the whole height of the letter apart, therefore the paper can be ruled evenly and every other line used for writing. For lower-case forms, the space needed between lines of writing is three times the height of the letter o. As ascenders and descenders are generally shorter than the body height of the letter, this measurement leaves some room for clearance between the lines. Allow extra space at first for italics with curving ascenders or flourished letterforms.

When starting to write words and full lines of writing, rule a left-hand margin on the page as well as horizontal guidelines and start each line at the vertical rule.

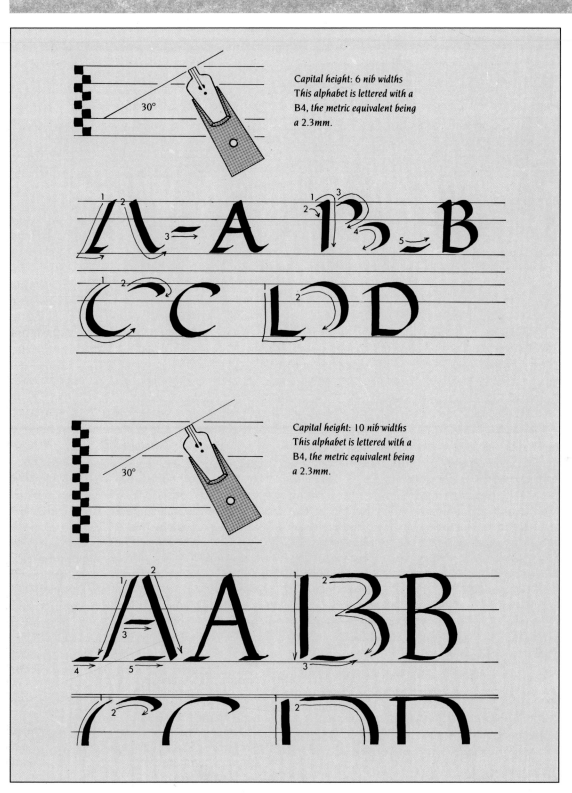

Capital height: 6 nib widths
This alphabet is lettered with a
B4, the metric equivalent being
a 2.3mm.

Capital height: 10 nib widths
This alphabet is lettered with a
B4, the metric equivalent being
a 2.3mm.

In calligraphy the proportion of a
given style is based on the
number of nib widths used for
the capital height, the x height,
and the ascender and descender
areas.

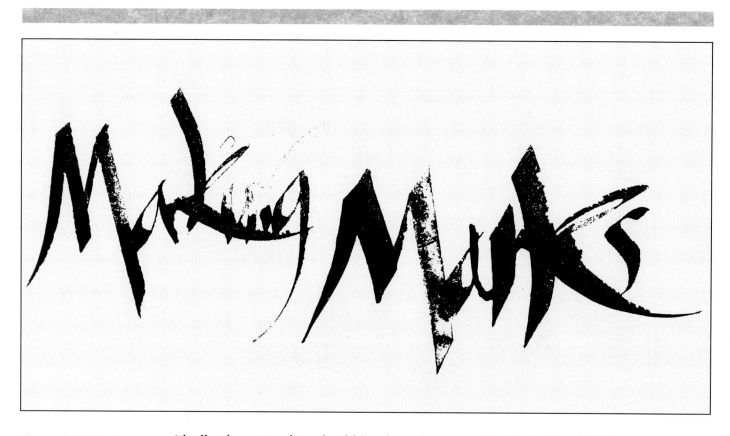

This example of modern free pen lettering uses contrasting thick and thin strokes and variations in weight and texture to capture the vitality and rhythm implicit in the words.

Ideally, the writing line should be the only reference, as the calligrapher will gradually gain a proper instinct for the even height and correct relative proportions of letters. In practice, a beginner may prefer to rule a writing line, a line to mark the body height of the letters and, if necessary, lines to indicate the extension of ascenders and descenders above and below the writing line. But Johnston remarked that 'writing between ruled lines is like trying to dance in a room your own height' and it should be remembered that it is essentially the pen that creates the form, not any principles of geometry or arithmetic planning. This is where calligraphy gains its true vitality. For the same reason, any temptation to sketch letterforms in pencil and fill them out with the pen should be resisted. For tentative calligraphers, practice with twin-points or a carpenter's pencil may instil some early confidence. but experienced penmanship will only be attained, naturally enough, through experience of using the pen.

SERIFS AND FINISHING STROKES

A frequently quoted axiom of calligraphy states that a practised scribe can construct a whole alphabet in a consistent style if given only the form of O and I. It has already been shown how O demonstrates the model for the skeleton form, whether it is round or elliptical, and also how the angle of the pen governs where thick and thin graduations will occur within the curves. The feature of an alphabet characterized by I, which gives the scribe the clue to formation of straight stroke letters, is the way the vertical stroke of I is finished at head and foot.

Hooked serifs, which are characteristic of italic writing and the modified tenth-century hand, are made by pushing the pen upwards slightly before following down into a vertical or oblique stroke. A similar motion is made just before lifting the pen at the base of the stroke. This type of serif may serve merely to tip the main stroke of a letter or it may be noticeably hooked and possess its own direction. As a

Tule tupahan onni,
pysy siellä pyytämättä,

Bickham

rule, these serifs come in from the left of the main stroke at the head of the letter and tail off to the right at the base. On a vertical stem this motion is made quite abruptly so the stem itself remains a true vertical; the serif should not curve into the main stroke but does literally form a hook on the head or foot. In general, the tails of letters that are fluid and oblique, as in K and R, are not hooked but follow a natural pen curve tapering to a hairline.

More formal serifs are constructed of two or three short pen strokes, creating a distinct shape to the head and foot of the letter and in the finishing cross-strokes. A horizontal or wedge-shaped serif is marked with a hairline at right-angles to the main stroke, and is then moulded into the form on a curve. This can be done in two ways. Either draw the horizontal hairline first and then, as a separate stroke, turn the pen to describe a fine curve into the stem; or make a curving stroke by first moving in from the horizontal and the right-hand edge and then sharpening this by laying in a short

vertical stroke over the curve. In Roman capitals the serif is centred on the stem and curves in from left and right.

Some extra dexterity is required of the calligrapher when twisting the pen on a serifed form, to ensure that the width of the serif stroke is kept in line with the stem. Finely curved hairlines and flourishes also respond to this motion and it is occasionally desirable to modify the curve of a structural stroke in this way. To twist the stroke the pen can be gently rolled between the fingers, altering the angle of the nib or lifting one corner of the nib away from the surface. Alternatively, the pen angle can be kept constant and the hand turned slightly from the wrist in a quick, smooth movement. As has already been described, only practice endows this sort of ability and if the calligrapher is sufficiently sensitive to the action of the pen, it will be possible to feel when the right kind of movement is achieved. This realization will be borne out by the visible results.

Flourished finishing strokes may also be used for signatures. The notable scribe George Bickham used controlled serifs to highlight this engraving he made of his signature (above centre). . Bickham was particularly interested in developing a practical business hand, which was presentable but not fussy.

Elaborate serifs draw attention to a piece of writing. This is a particularly useful technique when designing selling or display material, such as this piece by the Finnish calligrapher, Erkki Ruuhinen (top). The sentence translates as: 'May good fortune come to this home and remain there without being asked.'

Laying out guide lines

To begin with, look at the alphabet sample you wish to produce. Many of the samples in this book have a chequer-board pen width pattern which appears before the alphabet and indicates the proportions required to produce the alphabet, together with the adopted lettering angle at which the style should be executed.

It is important to start from the beginning with a method for laying out the sheet; let's take as an example the alphabet that appears on pages 78–79 of this book – Roman Sans Serif. (This style has a capital height of six nib widths, x-height of four nib widths, giving an ascender area of two nib widths and corresponding descender area of two nib widths.) Take a sheet of layout paper and draw a line parallel to the top of the sheet about 1½in (40mm) from the edge with a sharp 2H pencil. Take a pen that has an equivalent nib width to that used in the sample alphabet. A B4 is used for most of the exercises in this book but a 2.3mm nib is almost identical. From this base line step up six nib widths on the left of the sheet. They should be in a chequered pattern. The nib must be vertical to the writing line so that its full width is used when marking off.

Now mark off three nib widths below the line, two for the descenders and the third for interlinear space.

Take a strip of cartridge paper about 1in (25mm) by 9in (230mm) and place it alongside the chequered pattern. Transfer the measurements, the capital line, x-height line, base line, descender line and interlinear line; the units should be two, four, two and one respectively. Move the strip of card upwards so that the last line of interlinear area is at the capital line and repeat the process of transferring the measurements.

The card will hold 10 lines of lettering in all. It is a good idea to draw the lines across the strip so that each side of the marker can be used. To differentiate between lines of writing and interlinear space, mark an 'x' between the x-height lines and colour or shade the interlinear areas.

The strip should also contain useful information such as the size of nib, the style for which it is to be used and the interlinear measurement. Cover the marker with clear adhesive tape, the type that does not discolour with age. You might also tape the underside of the marker to keep it clean. A marker gauge now exists, which can be kept and used over and over again for transferring measurements for this nib size and alphabet. If a marker is made for each alphabet, it will reduce the time entailed in preliminary work.

Go back to the layout sheet and align the first base line with that of the marker, transfer the marker measurements to the sheet on the left-hand side and then move to the right-hand side of the sheet and repeat the process. Rule lines across the sheet to join up the measurements.

The beauty of the nib-width system for determining the height of lettering is quite simply that, irrespective of the nib size used, the proportions of the letterforms remain the same, provided that the nib widths are stepped off with the nib intended to do the lettering. Obviously a nib of half the width of that used to letter the first sample style would produce a lightweight rendering of that style.

A selection of marker gauges used when assessing depth of copy.

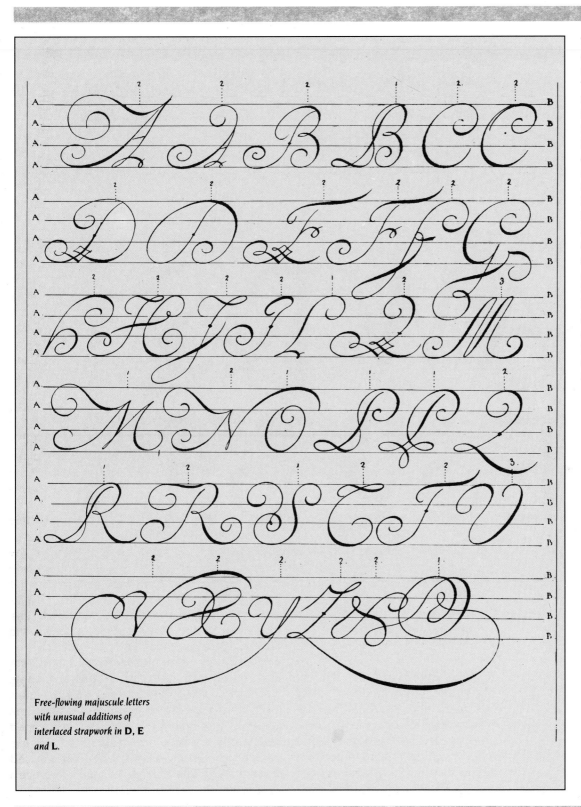

Free-flowing majuscule letters with unusual additions of interlaced strapwork in **D**, **E** and **L**.

These finely developed scrolled capitals demonstrate the versatility of copperplate style. The thick/thin contrast betrays their origin as edged-pen rather than pointed pen letters, though the narrow nib width creates a fluid and lightweight appearance. The construction of each letter is carefully controlled by the evenly spaced writing lines governing body height and internal features. The extended, looping flourishes at the heads and bases of the letter are systematically fitted to these guidelines. The calligrapher, French writing master Charles Paillasson (fl 1760), has allowed himself a final extravagant gesture in the billowing flourished tails wrapped under and around the letters on the bottom line of the alphabet.

Basic Letter Forms

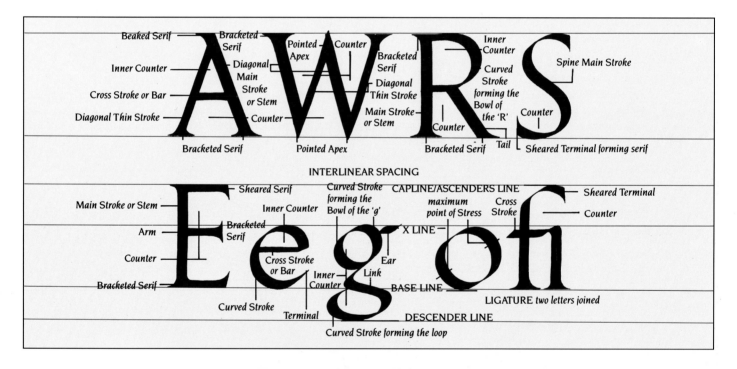

Beaked Serif | Bracketed Serif | Pointed Apex | Counter | Bracketed Serif | Inner Counter | Spine Main Stroke

Inner Counter | Diagonal Main Stroke or Stem | Curved Stroke forming the Bowl of the 'R'

Cross Stroke or Bar | Diagonal Thin Stroke | Main Stroke or Stem | Counter

Diagonal Thin Stroke | Counter | Counter

Bracketed Serif | Pointed Apex | Bracketed Serif | Tail | Sheared Terminal forming serif

INTERLINEAR SPACING

Main Stroke or Stem | Sheared Serif | Curved Stroke forming the Bowl of the 'g' | CAPLINE/ASCENDERS LINE | maximum point of Stress | Cross Stroke | Sheared Terminal

Inner Counter | Counter

Arm | Bracketed Serif | X LINE

Counter | Cross Stroke or Bar | Ear

Inner Counter | Link

Bracketed Serif | BASE LINE

LIGATURE two letters joined

Curved Stroke | Terminal | DESCENDER LINE

Curved Stroke forming the loop

Roman Classical Alphabet, far right.

Letter construction

In order to discuss the subject of letters, calligraphers, letter designers and students require terminology to describe the constituent parts of letterforms. When analysing a particular style, this nomenclature is used to define the various elements in a concise manner. There is no standard nomenclature to define constituent parts of letters but many of the terms are self-explanatory. The terminology used here is based on that employed by letter designers and therefore may differ from that found in calligraphic references. Many descriptions are repeated from letter to letter as these terms are used generally throughout the alphabet and are not necessarily confined to a specific letter. The parts and names illustrated refer to the Quadrata capitals (majuscule) and a complementary lower-case (minuscule) alphabet.

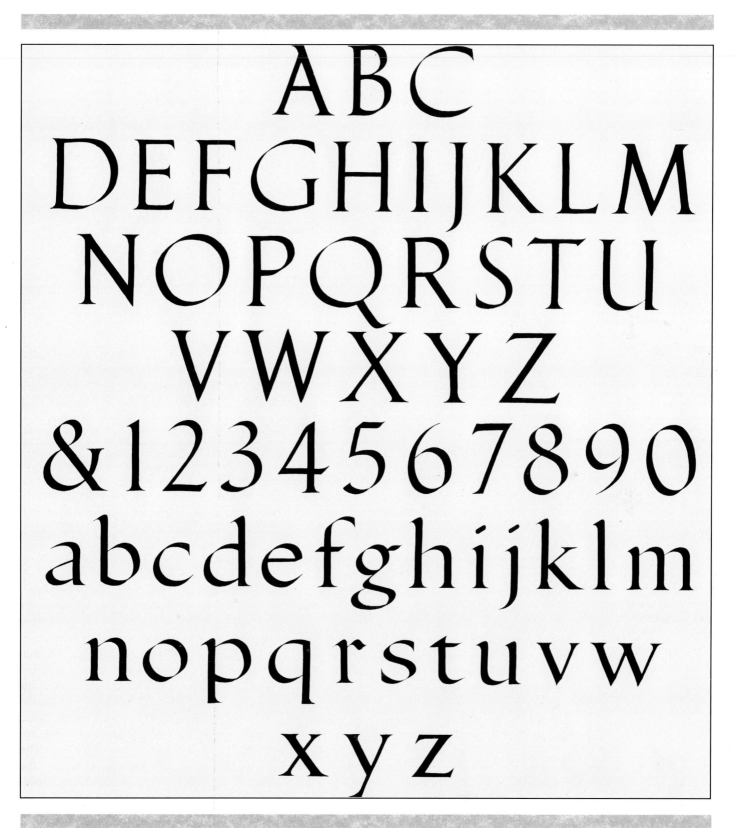

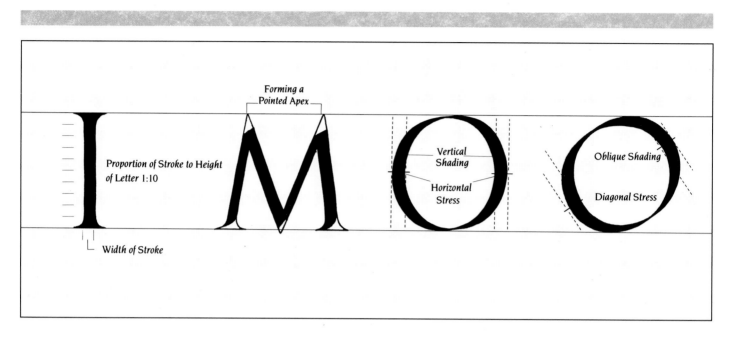

Quadrata is the criterion on which all subsequent styles are based. It is therefore of prime importance for students to associate themselves with this fine alphabet.

Roman is not just the name of the region of origin but is used more generally to describe any style appearing in a vertical attitude. The capital alphabet contains more straight lines than curves, and many letters have a combination of both vertical and horizontal strokes giving a squarish appearance, hence the word Quadrata. There is an architectural, geometric quality within the style which would account for the harmony created when lettering is used on buildings in stone.

Capital letters can be defined as having a uniform height throughout; that is, they are written between two parallel lines. The letters are contained within a capital line (top line) and a base line, with the exception of the letters 'J' and 'Q' which break the base line in some styles. The lines are also marginally broken by minor optical adjustments to certain letters where pointed apexes and curved strokes slightly overlap.

There are now two fixed points, the capital and the base lines, between which to construct the letters. There is, however, a problem. It must be decided how far apart the lines should be drawn. There is a definite relationship between the capital height and the width of the main stroke. In Quadrata the stem divides into the capital height 10 times, giving a ratio of 1:10. It is important to evaluate this ratio, as misinterpretation will result in an untrue reproduction of the style.

Once the height and weight ratios have been established, consideration must be given to the construction of individual letters. The Romans were a practical and efficient race, and their ability to rationalize and organize is reflected in the formal appearance of their design. The alphabet which follows has been produced with a pen and is based on formal Roman characters. If the forms are analysed, it will be noticed that there are similar characteristics between certain letters, the 'E', 'F' and 'L' for example.

It is also apparent that the widths of letters are not identical and that each character occupies a given area in width while retaining a constant height. This width is known as the unit value of the letter, the 'M' and 'W' being the widest and the 'I' and 'J' the narrowest. The unit width is a necessary factor in determining the final balance and poise of letters.

When letters are placed on a gridded square, an immediate visual comparison between the

letterforms is possible. The grid illustrated has been divided into units of stem width for convenience, giving an initial square for the capitals subdivided into 10 units of height by 10 units of width. The lower blank portion is for the lower-case letters, which appear after the capitals. The lower portion will then be used to accommodate the descenders of the lower-case.

Incidentally, the words 'lower-case' are a printers' term, now in common use to describe minuscule letters. It derives from the type-setters' cases which contained the metal or wooden letters. The capital letters of an alphabet were stored in the upper-case, the small letters stored in the lower-case.

The skeleton form of 'O' is a perfect circle that fits exactly to the basic square. 'Q' is also a circle, distinguished by its tail, which flows naturally from the base of the letter but does not cut the curve. 'M' and 'W' are based on the square, although the outer oblique strokes extend slightly beyond the boundaries, at the base of 'M' and at the head of 'W'. The curves of 'C','G' and 'D' follow the circular 'O', but are cut to nine-tenths of the square in the open 'C', the vertical stem of 'D' and the bar characteristic of 'G'.

The narrow letters 'B', 'E', 'F', 'I', 'J','K', 'L', 'P', 'R', 'S', 'X', 'Y' all fit into the half-square. The remaining letters, 'H', 'U', 'N', 'T', 'A', 'V', 'Z' are regularly proportioned within eight-tenths of the square. 'X' and 'Y', like 'M' and 'W', extend outside the rectangle in the oblique strokes, 'X' at the base and 'Y' at the head. Thus, there are four basic frames for the proportions of all Roman capitals. Each one is clearly distinguishable by the strong contrasts between straight and curved elements and square, triangular and circular shapes.

Certain modifications have been made to the position of cross-strokes and the curve of bowed letters to establish proportions that are optically satisfying. In a basic skeleton form, for example, 'B' can be, in effect, formed of two 'D' shapes, one on top of the other. The two bowed sections would then be equal, coming together at the centre line between top and bottom. In practice, the lower bow of 'B' is slightly enlarged and the two curving strokes meet above the centre line, otherwise the letter appears top heavy. The modification is subtle and it is a common mistake to exaggerate this difference, an over-compensation that should be avoided as it makes the letter inconsistent with the structure and proportion of other forms. Likewise, the lower bowl of 'S' should not be allowed to overtake the scale of the upper section.

The cross-strokes through the centre of 'E', 'F' and 'H' are placed slightly above the centre line, so that the bottom edge of the pen stroke sits on the line. (Note that in both 'E' and 'F' the top arm and cross-stroke appear equal in length, but the middle arm is slightly shorter, while the base of 'E' is slightly extended.) By contrast with the usual habit of fixing the optical centre of a letter just above the actual centre, the bowls of 'R' and 'P' drop below the centre line so the enclosed counter has a clean, open curve corresponding to the circular form of 'O'. The cross-stroke of 'A' is also lowered so that the enclosed triangular space is not cramped and disproportionate. The branching of 'Y' crosses slightly below the centre line whereas the oblique strokes of the 'X' cross slightly above the centre, leaving the lower triangle fractionally larger than the upper.

When analysing the construction of individual characters, it is essential for the student to fix their images firmly in his mind. The proportions of this style will be found to be indispensable as the student becomes more involved with letterforms, and the ability to draw on his experience of the classical Roman style will assist him when analysing other letterforms.

I have lettered this alphabet with a pen to illustrate proportion; it also shows that a classical Roman style can be achieved calligraphically. It is not my intention that the student begins lettering with this style. The construction of the letterforms is difficult in as much as they are not easily reproduced with a square-ended nib. Within the sample alphabet sheets there is a Roman style that has been simplified for use with the pen.

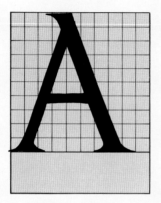

The 'A' occupies approximately eight tenths of the gridded square. Being a letter formed from triangular elements, it should appear almost symmetrical: the inverted 'V' shape should be balanced, not leaning to right or left.

The cross-stroke of the 'A' is positioned midway between the apex and the base line.

The 'B' occupies about half the width of the gridded square. The upper bowl of the 'B' is smaller than the lower and therefore the intersection is above the centre line. This is intentional: if both bowls were equal in size the letter would appear top-heavy.

The 'C' takes up about nine tenths of the width of the gridded square. Because it is a rounded form, the top and bottom curves project slightly over the cap and base lines.

The 'C' follows the left-hand curve of the 'O', but the upper and lower arms are somewhat flattened. The upper arm ends in a sheared terminal extended to form a beak-like serif.

Much in the manner of 'C', the 'D' follows the right-hand curve of the 'O' with the upper and lower curves extending from the initial cross-strokes, so slightly breaking the cap line and base line. The stem appears slightly thickened towards the base cross-stroke where it is joined with a curved bracket. The serifs are bracketed on the left hand of the stem.

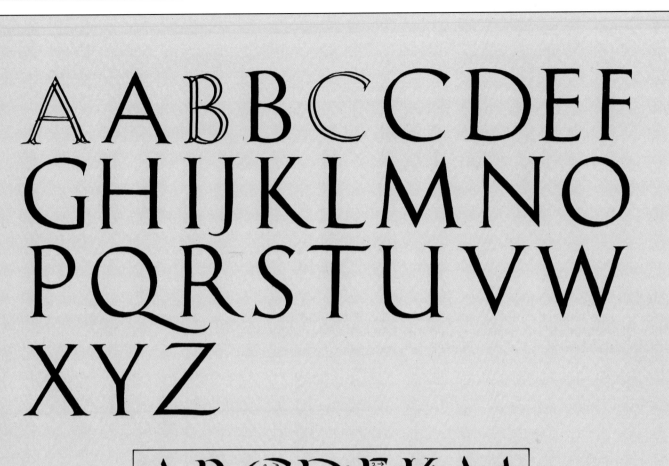

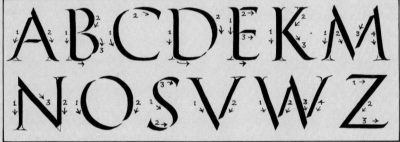

The standard Roman capitals
alphabet with serifs is written
with the pen at an angle of 30°
(top). Each stroke is 1/10 as
thick as its height. The direction
and order of strokes is shown
(above).

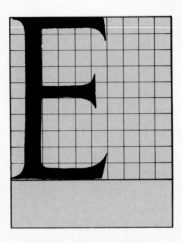

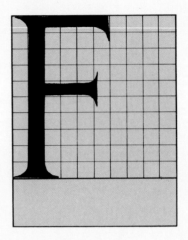

The 'E' occupies about half the width of the gridded square. The upper arm of the 'E' is slightly longer than the middle arm, which is placed high on the centre line, making the upper counter smaller than the lower. Again this is optically necessary. The lower arm projects a little beyond the upper arm with both ending in sheared, bracketed serifs.

The 'F' also occupies about half the width of the gridded square, and to a great extent may be regarded simply as an 'E' minus the lower arm.

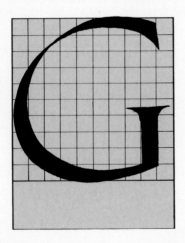

The 'G' takes up about nine tenths of the width of the gridded square. Another rounded form, its top and bottom curves project slightly over the cap and base lines in order to be optically compatible with letters ending in flat serifs.

'G' follows the lines of the 'C', with the stem of the 'G' rising from the lower arm to within five tenths of the letter height and terminating in a bracketed serif.

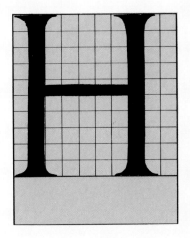

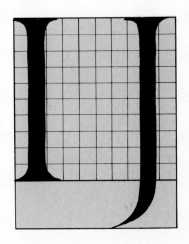

'H' occupies approximately eight tenths of the gridded square.

The cross-bar of the 'H' should be slightly above the centre line; otherwise it seems to be slipping down the main stems.

The 'I' and 'J' take up approximately three tenths of the gridded square. The 'I' is a simply constructed letter. Nevertheless, it is important because it sets the standard for the alphabet in height and stem width.

The 'J' does not appear in the inscription on the Trajan Column where its present-day sound is represented by an 'I'. 'J' is written like an 'I' minus the base-line bracketed serif, where the stroke continues through the base line and curves to the left, ending in a pointed terminal. The length of the stroke is contained within the descender area.

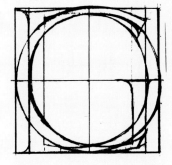

A certain uniformity in proportion holds between different letterforms within the same alphabet. Thus, the letters CDG all occupy 9/10 of the square that contains the letter O.

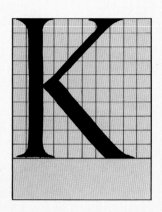

The 'K' occupies approximately eight tenths of the gridded square.

For reasons of optical compatibility, the two diagonal strokes of the 'K' meet at a point which is slightly above the centre, making the lower counter fractionally larger than the upper counter.

The 'L' occupies about half the width of the gridded square.

To a great extent the 'L' may be regarded as an 'E' without the upper arms. The stem at the cap line has the addition of a bracketed serif on the right.

The 'M' is one of the widest letters of the alphabet, occupying slightly more than the square with the diagonal strokes breaking the grid at both sides. The true Roman 'M' has pointed apexes, along with the 'A' and 'N', which are easily cut with a chisel; but when a pen or brush is employed, other forms of ending the strokes are more natural.

In order to achieve a pointed apex the pen strokes end short of the cap and base lines and are then brought to a point. The apexes project beyond capital and base lines in order to obtain optical alignment with letters ending in square terminals or with beaked or bracketed serifs. Because the apexes of the 'M' in the example alphabet end in a beaked serif, this will naturally be carried through to the 'A' and 'N' to give continuity. The straight, thin strokes in the 'M' and similar letters are approximately half the thickness of the main stroke, but these strokes do alter because of the fixed lettering angle of the pen.

The 'N' occupies approximately eight tenths of the gridded square.

The pointed apex of the 'N' should protrude below the base line; the upper left-hand serif should be beaked.

The widest point of the thick stroke of the 'O' is marginally wider than that of the stem of the 'I'. In a free-drawn letter, that is a letter drawn and then filled in, this is an optical adjustment made to compensate for the tapering or thinning of the stroke towards the thinnest part of the letter. Without this alteration the curved stroke would appear optically thinner than the stem of the 'I'.

In calligraphy, the adjustment to thicken the curved strokes is automatic because of the oblique angle of the pen to the direction of writing. The thin strokes are substantially thinner than half the width of the main stroke, due to this same action of the pen. If desired, these thin strokes can be thickened to compare more favourably with the straight thin strokes.

The widest point of the curved stroke is known as the 'maximum point of stress' and in this example it can be said that the letter has diagonal stress with oblique shading. There are many styles which have horizontal stress with vertical shading.

The 'P' occupies about half the width of the gridded square. The letter at first glance resembles a 'B' minus the lower bowl. Closer inspection shows that the bowl is larger than the upper bowl of the 'B'. The cross-stroke joins the bowl to the stem below the centre line.

The 'O' sets the standard for all curved letters, and the 'Q' can be said to be an 'O' with an added tail. It is advisable to take note of the point at which the tail joins with the curved stroke. In some alphabets the 'Q' has a tail that appears to emanate from the lower left-hand curve of the letter, as an extension. To many calligraphists this is undesirable because the tail should definitely be a separate stroke.

The 'R' occupies approximately eight tenths of the gridded square. The upper part of the bowl projects above the cap line. The top of the lower cross-stroke which joins the bowl of the 'R' is positioned on the centre line. Careful note should be taken of where the tail of the 'R' meets the bowl.

The upper counter of the 'S' is smaller than the lower counter, with the letter sloping slightly to the right. The diagonal spine is of uniform thickness until it tapers to meet the curved arms. The 'S' is a diagonally stressed letter, having this characteristic in common with the 'A', 'K', 'M', 'N', 'R', 'V', 'W' and, in this alphabet, the 'Z', which is the only letter with a thick diagonal stroke running from top right to bottom left. The upper and lower arms end in sheared terminals and fractionally extend to form beak-like serifs. It is important for balance that the lower counter is slightly larger than the upper counter. This gives the 'S' a slight forward tilt, making it one of the hardest letters in which to achieve good poise.

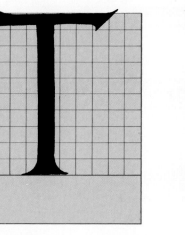

The 'T' occupies approximately eight tenths of the gridded square.

The cross-bar of the 'T' is sheared to the lettering angle on the left and right sides, ending in a slight serif. The spurs added to the serifs protrude above the cap line.

The 'U' occupies approximately eight tenths of the gridded square.

The curved stroke of the 'U' projects below the base line.

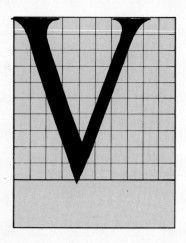

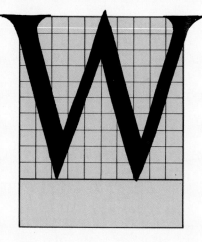

The 'V' occupies approximately eight tenths of the gridded square. Formed from triangular elements, the 'V' should appear almost symmetrical: balanced, not leaning to right or left.

The 'W' is perhaps the widest letter of the alphabet. It does not appear in Roman inscriptions but is a medieval addition to the alphabet. In Latin inscriptions 'V' stood for both the 'U' and 'V' sounds – hence the name 'double U', drawn as two 'V's virtually joined together, with minor adjustments. The 'U' symbol was a later development, perhaps to avoid confusion.

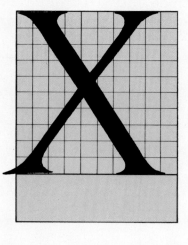

The 'X' occupies approximately eight tenths of the gridded square. Like the 'V' formed from triangular elements, the 'X' should appear almost symmetrical: balanced, not leaning to right or left.

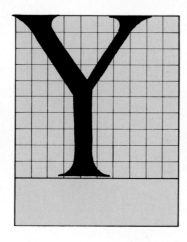 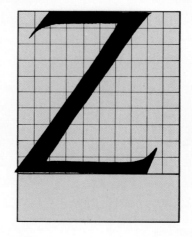

The 'Y' also occupies approximately eight tenths of the gridded square. Similarly containing triangular elements, the 'Y' too should appear almost symmetrical: balanced, not leaning to right or left.

Finally, the 'Z' also occupies approximately eight tenths of the gridded square.

However, the 'Z' is a problem letter as the main diagonal stem requires a change of pen angle to thicken the stroke. Otherwise the stem would appear as a hairline-thin stroke. This makes it difficult to execute with the pen.

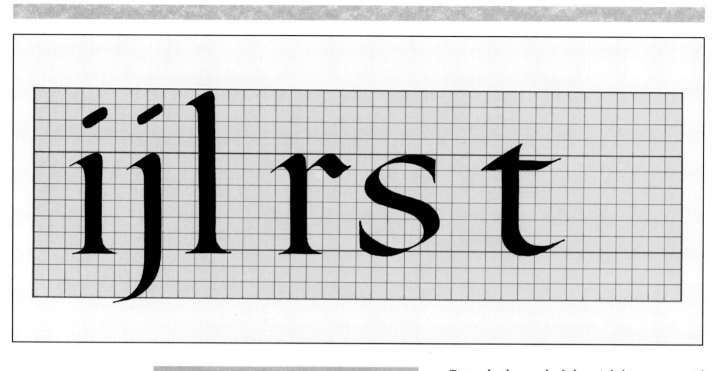

The development of lower-case (minuscules)

The Quadrata and Rustic capitals were followed by uncial, born of the need to write more quickly while still maintaining a formal style. Uncial is a true pen form with a simple construction and comparatively clean finishing strokes. Uncial was the literary hand for fine books from the fifth to the eighth century. The letterforms were more rounded than traditional Roman capitals. The chief characteristic letters within the style were the 'A', 'D', 'E', 'H' and 'M' and, although they were still written between the capital and base lines, certain letters, namely the 'D', 'F', 'G', 'H', 'K', 'L', 'P', 'Q', 'X' and 'Y', began to have longer stems which marginally broke through the cap and base lines.

Uncial was followed by half-uncial and here some letters are seen predominantly to break through the writing lines forming ascender and descender areas. Letterforms were modified, notable the 'a', 'b', 'e', 'g' and 'l', with the remaining letters receiving only minor amendments, if any at all.

Towards the end of the eighth century, with the revival of learning, came a reform of the hand in which works of literature were to be written. The emperor Charlemagne, who governed a vast area of Europe, commissioned the abbot and teacher, Alcuin of York, to rationalize and standardize the various minuscule scripts which had developed. Alcuin studied the former styles of Quadrata, Rustic, uncial and half-uncial and developed a new minuscule as a standard book style. This has become known as the Carolingian minuscule after its instigator, the emperor Charlemagne. Calligraphy now entered a new era.

Although the Romans used mainly capital letterforms, I have included a classical lower-case alphabet, together with Arabic numerals, to complement the capital forms previously described, and to give the student an insight into their construction. The letters and numerals that follow are of classical proportions and, once their relative widths and construction details have been mastered, knowledge of them will stand the student in good stead for lettering the sample alphabets in this book.

The letters have been placed on a grid which consists of squares of stem width:

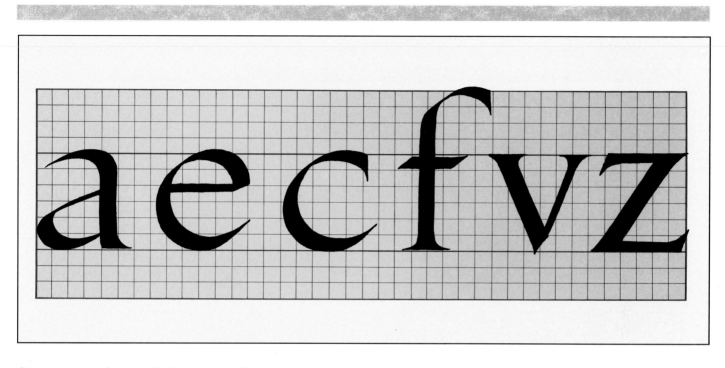

thirteen units deep, with four units allocated for the ascenders (those letters which reach the cap or ascender line, the 'h' for instance), six units for the x-height (that portion of the grid which contains letters such as the 's') and three units below the x-height (to accommodate the descenders of letters such as the 'g' and 'y'). I have grouped together the characters with common widths, starting with the narrowest and ending with the widest.

The first, and narrowest, group comprises the letters 'i', 'j' and 'l'. They are easily constructed, with the humble 'i' and 'l' setting the pattern for straight letters. The dot over the 'i' and 'j' can be round or flat and is usually positioned about midway between the x and ascender lines. The 'j' initially follows the 'i' but extends below the base line where it curves to the left, ending in a pointed terminal.

The next grouping contains three characters, about five units wide: the 'r', 's' and 't'. From the main stem of the 'r' there is a small shoulder stroke which should not be overdone. The 's' is constructed in the same manner as its capital.

The main stem of the 't' starts obliquely, a little way above the x line, moving to the right before reaching the base line and ending in a pointed terminal. Like the 'f', the cross-stroke is finished with a slight upwards movement.

The third group contains the 'a', 'c', 'e', 'f', 'v' and 'z' and, with the exception of 'f', they are all contained within the x-height.

The 'a' starts from a pointed, curved arm which leads into the main stem. The bowl starts from the stem above the centre line of the x-height and moves to the left before the downward curve. It rejoins the stem above the base line, leaving a triangular shape. The 'c' follows the left-hand stroke of the 'o', the upper arm being slightly straightened and ending in a sheared terminal which is extended to form a beak-like serif. The lower arm ends in a pointed terminal. The 'e' follows the 'c'; the upper arm, however, is not straightened but flows round. The bowl is formed by a cross-stroke above the x-height centre.

The 'f' is an ascending letter, starting its main stroke below the ascender line with the arm projecting to the right and ending in a sheared beak-like serif. The cross-bar is positioned just below the x line. The 'v' and 'z' both follow the same construction as their capital counterparts.

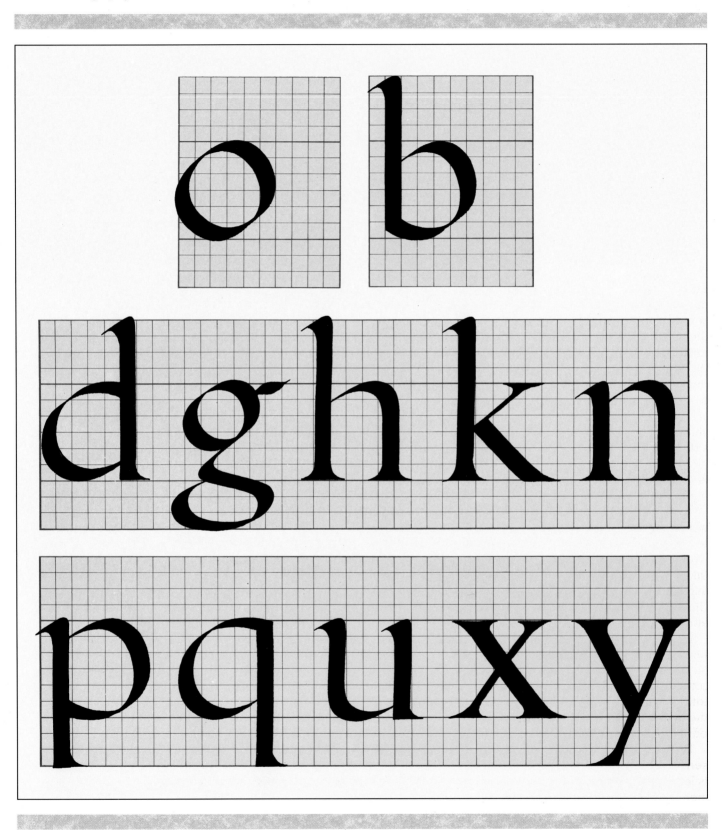

The two letters in the subsequent group take up approximately six-and-a-half units in width. The 'b' is an ascending letter, the main stem swinging to the right before it meets the base line. The 'o' is contained within the x-height with the exception of minor optical adjustments at the x and base lines.

Each letter in the penultimate group occupies about seven units. The group comprises 'd', 'g', 'h', 'k', 'n', 'p', 'q', 'u', 'x' and 'y'. There are three letters with ascenders ('d', 'h', and 'k'), four letters with descenders ('g', 'p', 'q' and 'y'), and three contained within the x-height.

In the 'd', at the point where the lower curve of the bowl meets the main stem, there should be a triangular space formed by the upward movement of the curved stroke. The upper serif of the main stem projects slightly above the ascender or cap line.

The old-style 'g' is very difficult to master. In this style the bowl does not take up the whole depth of the x-height: instead it occupies just over three units. It then joins the link which carries down to the base line and then turns sharply to the right and ends forming the right side of the loop. The loop is accommodated within the three-unit descender area. The ear is attached to the bowl at the right side, leaving a v-shaped space.

The 'h' and 'n' are formed in a similar fashion, although the 'h' has the first stem lengthened to form the ascender, with the serif extending over the ascender line. The letter 'n' can be taken as an 'h' without the ascender. The ascender stem of the 'k' is like the 'h' and the diagonal thin stroke and the tail intersect just above the centre of the x-height.

With the 'p', the join of the lower part of the bowl to the stem is somewhat flattened. A serif is attached to the bowl at the top left-hand corner. The 'q' is not a 'p' in reverse but is totally different in character, having no serif at the x line and with the upper stroke of the bowl being straightened to meet the stem.

The 'u' is not an inverted 'n'. The upper serifs protrude beyond the x line and a space is left where the curve makes its upward movement to meet the second stem. In the 'x', the

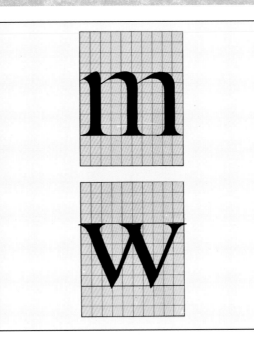

point of intersection of the thin and thick strokes is above the x-height centre, making the lower counter larger than the upper. The diagonal thick stroke of the 'y' does not reach the base line but is intersected by the thin stroke, which follows through to the descender line where it ends in a flat, bracketed serif.

The final grouping, containing the widest letters, again comprises only two. The lower-case 'm' and 'w' occupy approximately 10 units, and both letters are contained within the x-height. In the 'm', observe the point at which the curved shoulder of the second stroke meets the stem of the first – the second shoulder intersects at the same height. The serif of the first stroke and both shoulders, because they are curved, are positioned so that they break the x line to give optical alignment with the letters 'v', 'w', 'x', 'y' and 'z'; their tops are either bracketed serifs or, in the 'z', a cross-stroke.

The 'm' is not two 'n's joined, as the inner counters of the 'm' are narrower than that of the 'n'. The apexes of the 'w' extend slightly below the base line and the inner apex is the x line. This shows that the diagonal strokes are positioned correctly.

constructed carefully they can appear to be falling over. This is probably because they are mainly asymmetric in form, with the exception of course of the 0, 1 and 8, which are basically balanced.

If the curve of the 2 is allowed to project beyond the base cross-stroke, it will appear to be leaning to the right. If the tail of the 9 is not carried sufficiently far to the left, the figure will appear to lean to the left; if too far, it will look as if it is leaning to the right. The 9 is not an inverted 6. The join of the small curved stroke to the main curved stem alters in each case, making the inner counters slightly different in shape.

The upper counters of the 3 and 8 should be smaller than the lower; otherwise the characters will be top-heavy. The cross-bar of the 4 is fairly low on the stem so that the inner counter does not appear too small. The diagonal stroke of the 7 cannot extend too far to the left: once it goes beyond the alignment of the upper stroke, it makes the letter look as if it were leaning backwards. If the cross-stroke of the 5 is too long, it too can appear to lean to the right. Finally, it would be noted that the numeral 0 is compressed and not by any means the same as a letter 'O'.

NUMERALS

The Romans used letters of the alphabet for their numeric reference. We are all familiar with the Roman-style numerals when applied to a clock face, but perhaps not so with M = 1,000, D = 500, C = 100 and L = 50. It takes little imagination to see that mathematical calculations could be made easier by changing the symbols. The Arabs did exactly that and based their system on 10 numeric signs, the 'Arabic numerals' we use today. They can be either of uniform height ('lining numerals') or of varying height ('old style' or 'hanging numerals'). In the latter style the 1, 2 and 0 appear within the x-height, the 6 and 8 are ascending numerals and the 3, 4, 5, 7 and 9 are descending characters.

The main characteristics of the numerals need little explanation, but a few points should be noted. For example, if numerals are not

OTHER CHARACTERS

Within our written language there are of course many other symbols such as parentheses, exclamation marks and question marks, to name but a few. These will become natural enough to create once the student starts practising calligraphy.

The character '&' is known as the ampersand. This is possibly a corruption of the mixed English and Latin phrase 'and *per se* and'. It is an ancient monogram of the letters 'e' and 't', the Latin word *et* meaning 'and'. The *et* in this instance is not reflected in the character on the grid, which occupies nine units in width. The upper bowl is much smaller than the lower with the angle of the diagonal stroke cutting through to form a semicircular counter and the tail ending in a bracketed serif. The upward tail to the bowl ends with a bracketed serif above the centre line.

Alphabets: Roman

When copying an alphabet look for its basic characteristics and try to distinguish its skeleton form and the pen-made modifications to that form. Study the proportion of letters in height and width, between the body of a letter and the rising and falling strokes, and the general shapes of curving letters, whether they are round or elliptical, tilted or vertically stressed. Identify the weight of the lettering, the pen angle, the relationship of thick and thin strokes and the sequence of construction within each letter. These are the elements that govern the family likenesses between letters in an alphabet. They are expressed in the nature of curved strokes, the internal spaces in the letters, the serifs and finishing strokes and the joining of strokes – such as the way arches and bowls are attached to the stem of the letter. Calligraphy is much more vital where these innate characteristics have been understood than where the calligrapher merely attempts to copy the letters by eye.

ROMAN CAPITALS

The classical Roman capitals are not easy to construct as natural pen letters, because the forms were originally modified by stone-carvers and adapted to the action of the chisel. However, they were also written with the pen, which gives the strokes their thick and thin contrast, although the finest surviving examples of Roman capitals actually occur in monumen-

tal inscriptions in stone. Roman square capitals are of enormous interest to the calligrapher as the origin of other written forms, and also because they are regular and finely proportioned. There have been many modifications of the original Roman lettering, which exaggerate or modify the thick-thin contrast and the construction of serifs to simplify the calligrapher's task.

The skeleton Roman alphabet is based on strict geometric models, which are optically adjusted in pen lettering to maintain a balance within the letterforms themselves and in their relationships to one another.

Roman Sans Serif alphabet

Roman in this instance refers to a vertical style as opposed to an inclined style, which is called italic. It has no affinity with true Roman lettering which has serifs at the stem terminals. Sans Serif means without serifs, 'sans' translating from French and Latin as 'without'.

There are many type styles used in printing which are sans serif and they have become very popular in recent times. This style of lettering was popular in Victorian times and was often referred to as Grotesque lettering.

Roman Sans Serif provides an excellent introduction to lettering mainly because it is clean and crisp and requires the minimum of directional changes to form the letters. This

FRAGT NICHT/
WAS EUER LAND
FÜR EUCH TUN WIRD
FRAGT/
WAS IHR FÜR EUER
LAND TUN KÖNNT
FRAGT/
WAS WIR GEMEINSAM
FÜR DIE FREIHEIT
DER MENSCHEN
TUN KÖNNEN

JOHN F KENNEDY

does not imply that the style is simple to produce – far from it. The very nature of the alphabet is one of precision, requiring accuracy in construction and giving no cover for mistakes. By this I mean that there are no additional embellishments to distract the eye, so that the letters must be well formed if they are to be pleasing. Once the student has become proficient in producing this style, it will not be difficult to attain the additional movements necessary to create the other sample alphabets in this book.

Roman Sans Serif is a particularly useful style for handbills, posters, notices and the like, where communication is of the essence. It is an extremely legible style, giving high character recognition, and is easily adapted to condensing or expanding the forms in equally consistent and legible fashion.

Choose a nib that is the same size as that used to letter the sheet – a B4 or ³⁄₁₆in (2.3mm). If unsure, take the nib and measure it against the pen drawing at the top of the column, as this is drawn to actual size. If the student does not possess a nib that is actual size, he will have to take the nearest to it and step off the nib widths as indicated under 'Laying out guide lines'. Then the guide lines should be drawn and the style copied. The pen angle is approximately 30° to the writing line. Set up the drawing for general calligraphic work and not for tracing.

If using a B4, take the book and lay it on the drawing board as for tracing. Take the layout sheet with pre-drawn guide lines and start by tracing the letterforms, not forgetting to use a guard sheet to keep the work free from grease and dirt. The sample alphabet shows the breakdown of strokes for the forming of each letter. The arrows denote direction of stroke and the numerals the order in which the strokes are produced. The majority of strokes are made with finger and wrist movement only. However, some of the longer diagonal strokes may require some arm movement, depending upon the dexterity of the individual. For the diagonal strokes of the 'Z', both capital and lower-case, and also of the numeral '7', the angle of the pen has been changed to almost parallel to the writing line.

The nib must be kept in contact with the writing surface during the forming of any stroke, but it is lifted from the surface upon completion. Skipping is the result of the pen not being in contact with the paper. This can be recognized by an unevenness in straight strokes, where a thickening and thinning in stems appears, and by broken curves in round forms. Always draw the pen; never push the nib.

Once it is felt that the letterforms being produced resemble those in the sample, continue to produce the forms without tracing them. The drawing board must then of course naturally be set up for general work and not for tracing.

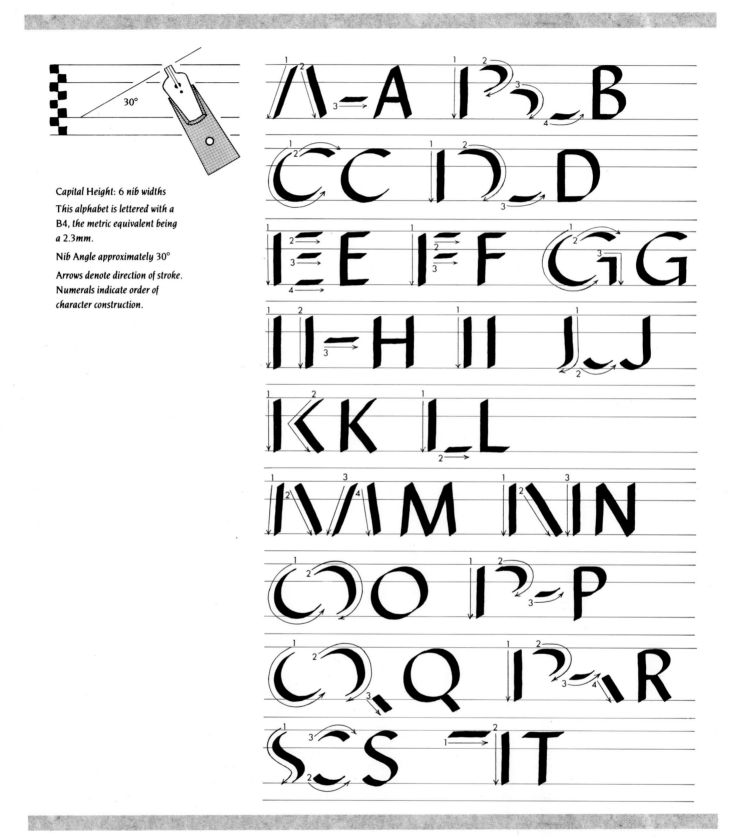

Capital Height: 6 nib widths

This alphabet is lettered with a B4, the metric equivalent being a 2.3mm.

Nib Angle approximately 30°

Arrows denote direction of stroke. Numerals indicate order of character construction.

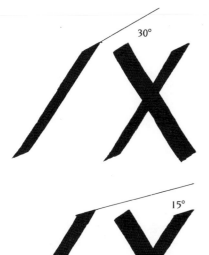

30°

15°

Nib Angle changed to 15° for the
thin diagonal stroke of the X.

Nib Angle changed to 15° for the
diagonal stroke of the Z.

30°

15°

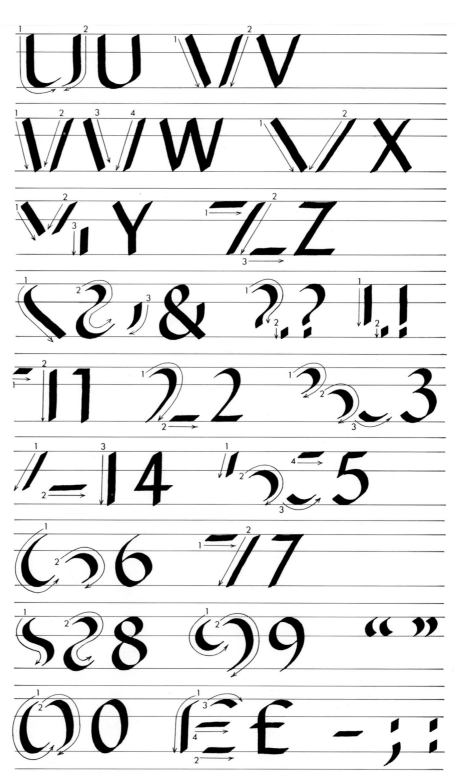

Roman Serifed alphabet

This style is based on Edward Johnston's Foundational Hand, which was modified from a tenth-century manuscript. In construction it is similar to Roman Sans Serif, but with the addition of serifs to give the style its character. These serifs are formed either by a change of direction, as in the serif at the foot of the thin diagonal stroke of the 'A', or by a second curved stroke into the main stem, such as that at the cap line of the 'B'. There are also tapered terminals, which are formed by a curving of the stroke ending at the pen angle, giving a point. This can be seen in the main stem of the 'A'.

The alphabet is lettered at an angle of 30° throughout with the exception of the capitals 'N', 'X' and 'Z'. The angle for both vertical strokes of the 'N' has been changed to 45° to give a slightly thinner stroke. The thin diagonal

This piece of text is, perhaps, a little ambitious for the beginner. It illustrates clearly how words can be manipulated to create a graphic image. The illustration adds to the design and holds the text together.

stroke of the 'X' has been lettered at 15° from the horizontal in order to give the stroke some body and keep it more in line with the thin diagonal strokes of the 'V' and 'W'. The 'Z' is the only letter that, when lettered with a 30° angle, has a main diagonal stem which is less in weight than the horizontal strokes. I feel that this anomaly should be overcome and have therefore adjusted the angle to 15° from the horizontal to give the stroke some stature. The lower-case 'z' also requires this change.

As a guide, if the main strokes of any letter are regarded as being the trunk of a tree, then all other strokes emanating from the stem should be of a weight that the main stem can support. This, I hope, explains my concern with the letter 'Z'. All these above adjustments have been made to give the letters concerned a better relationship with other characters – to achieve harmony and continuity, basic aspects of true calligraphy.

However carefully the letterforms are drawn, there will undoubtedly be a slight deviation from the 30° angle. Provided that it is only minor, it will not measurably affect the end result.

The guide lines should be drawn as indicated at the top of the first page of the alphabet. The numerals fall within the x-height area but the student can, if he wishes, increase the size to that of the capitals. Most of the characters are lettered with finger movement only, although the longer strokes may need some arm movement coming from the shoulder.

Once the alphabet in its present form has been mastered, the student may wish to letter the style in the following proportions.

	ascenders	x-height	descenders
nib widths	2	4¼	2
nib widths	2½	5	2½

This exercise is well worth the effort as it will show how a letterform changes in character when minor proportional adjustments are made. The alphabet style should, nevertheless, retain its general appearance and flavour once the nib values are changed. The overall effect of the proportional changes would be to make a page of text appear lighter.

"At the end of that time I will ask you a riddle. If you guess it the bargain is ended. But if you cannot guess it you must be my servants through all eternity"

"I WILL GIVE YOU SEVEN YEARS OF FREEDOM" SAID THE DRAGON

Capital Height: 6 nib widths
This alphabet is lettered with a
B4, the metric equivalent being
a 2.3mm.
Nib Angle approximately 30°
Arrows denote direction of stroke.
Numerals indicate order of
character construction.

Nib Angle changed to 45° for
the vertical strokes of the N.

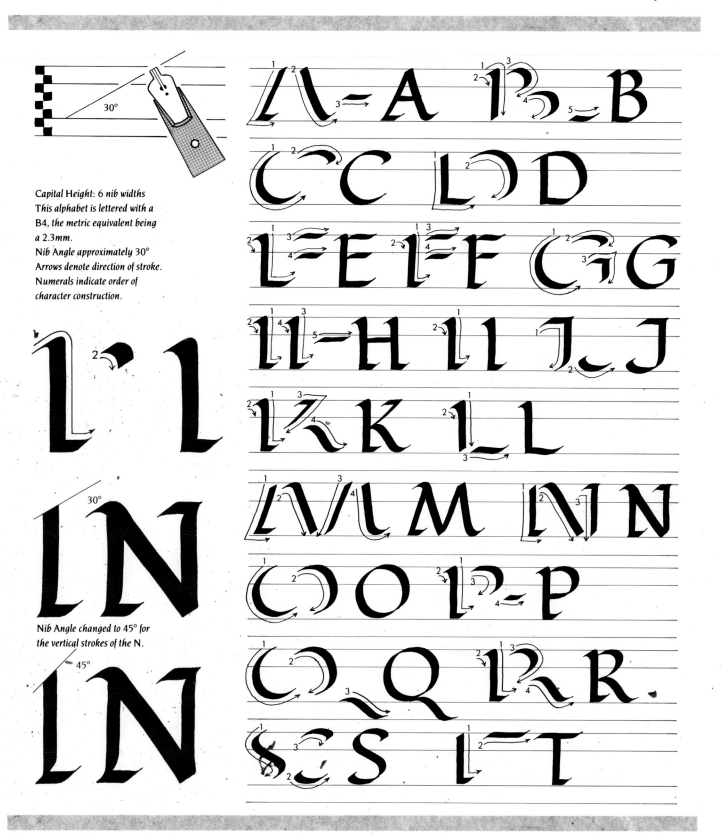

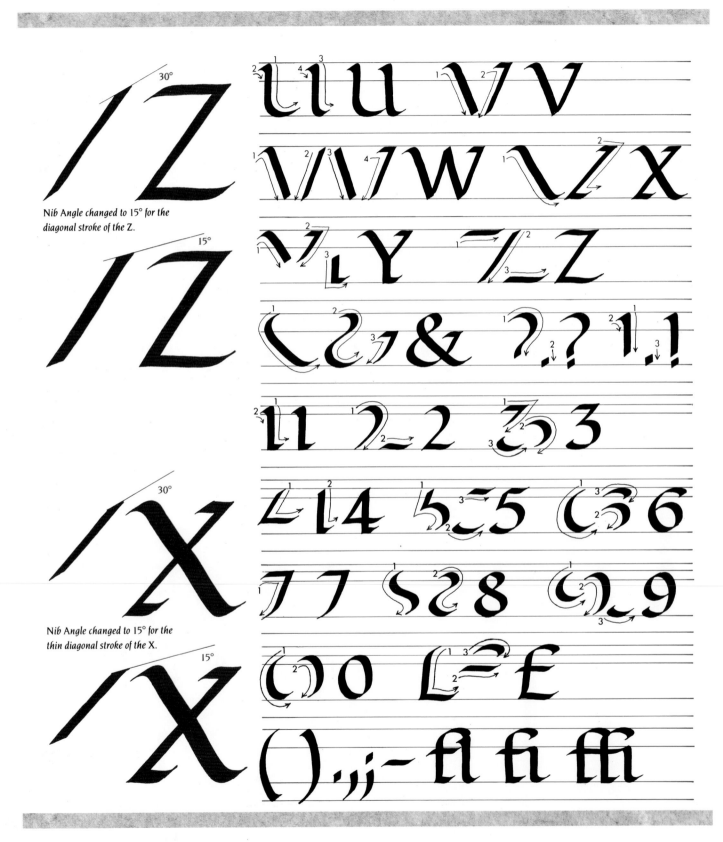

Nib Angle changed to 15° for the diagonal stroke of the Z.

Nib Angle changed to 15° for the thin diagonal stroke of the X.

Ascenders: 2 nib widths

'x' height: 4 nib widths

Descenders: 2 nib widths

Classic Roman alphabet

This style has been included as an alternative to the traditional Roman form, Quadrata, which is an extremely difficult letterform to produce with a pen. To form the serifs requires many strokes using just the edge of the pen. However, with this Classical Roman alphabet, the serifs have been simplified for ease of lettering with the pen; so it may not be a true classic Roman but will pass as a pen-rendered version. Here the serifs are either formed at the end of a curved stroke by slightly hooking the pen or by a completely separate stroke, lettered at a shallower angle than that of the main stroke construction.

The letterforms are made with a pen angle of 30°, with a few exceptions. The vertical strokes of the capital 'N' are lettered at a nib angle of 45°. This steeper angle means that the vertical strokes will appear narrower, and the contrast of weight is more in keeping with other letters in the alphabet. The diagonal strokes of both the capital and lower-case 'z' also have an adjustment to them. Here the main stroke is lettered with the pen angle parallel to the horizontal, giving the main stem more body.

The horizontal serifs are lettered at a pen angle of 20°, which gives a reasonable proportion with the thin strokes in the alphabet.

The serifs on the upper main stem of the 'B', 'P' and 'R' are extensions of the thin cross-strokes which form the upper bowls of each letter.

Where white areas are left between serifs and main or thin strokes, they should be filled in afterwards.

The accompanying numerals are lining numerals, lettered to the capital height. Hanging numerals may, however, be used, should the occasion arise.

(For an explanation of the difference between lining and hanging numerals see page 74; for an actual example of hanging numerals see page 118.)

When lettering in Classic Roman, a simple, centred layout is often all that is needed. The letters speak for themselves.

JULIUS CÆSAR

Friends, Romans, countrymen
lend me your ears;
I come to bury Cæsar
not to praise him.

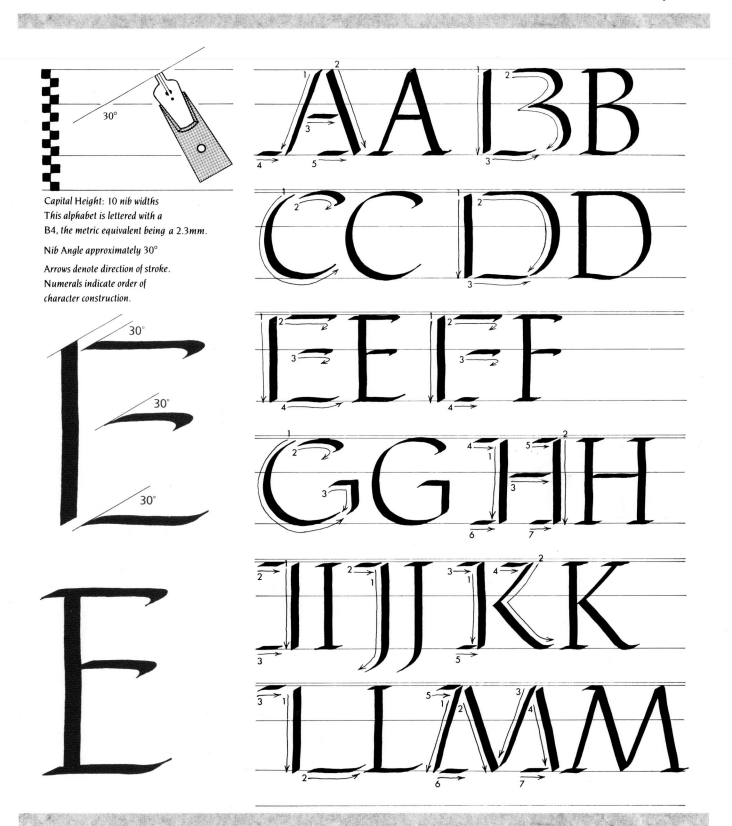

Capital Height: 10 nib widths
This alphabet is lettered with a
B4, the metric equivalent being a 2.3mm.

Nib Angle approximately 30°

Arrows denote direction of stroke.
Numerals indicate order of
character construction.

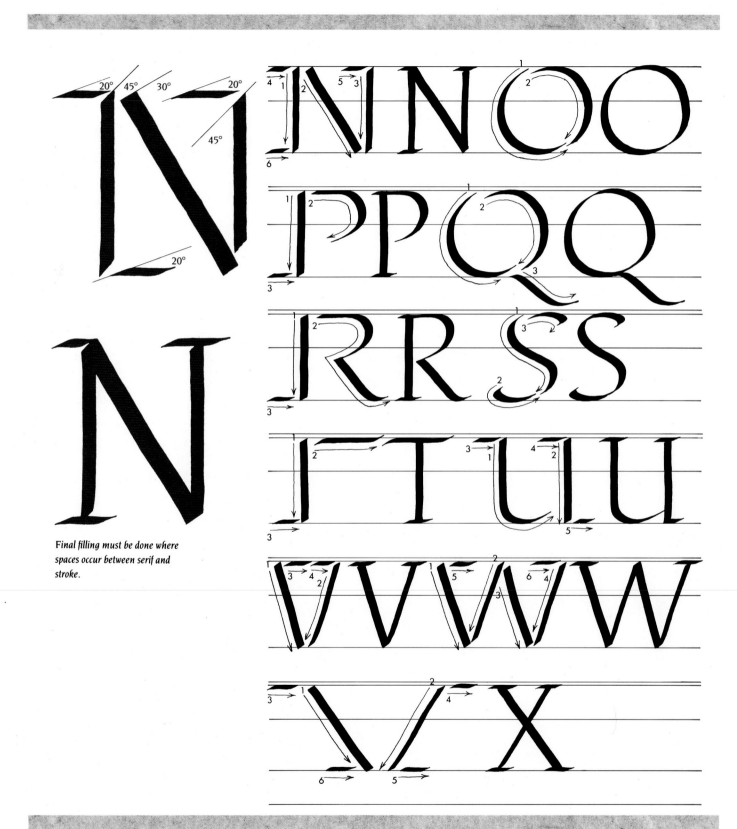

Final filling must be done where spaces occur between serif and stroke.

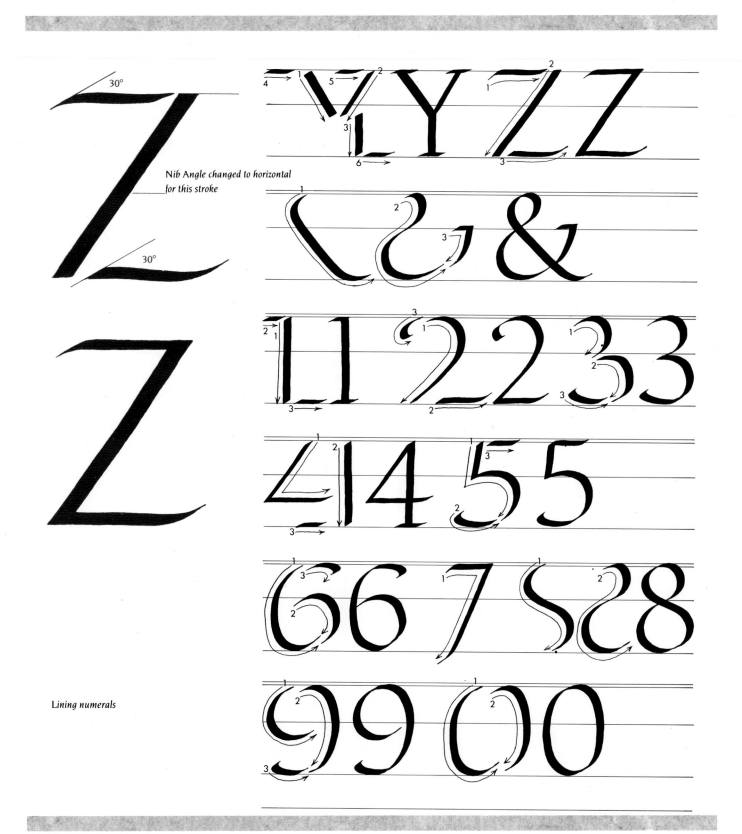

30°

Nib Angle changed to horizontal
for this stroke

30°

Lining numerals

Ascenders: 4 nib widths

'x' height: 6 nib widths

Descenders: 4 nib widths

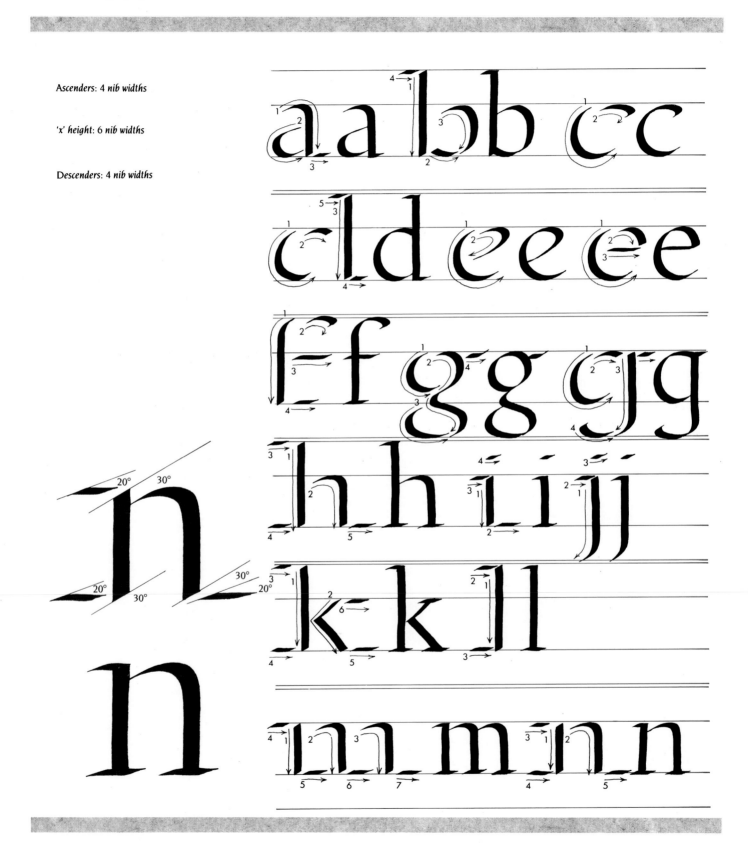

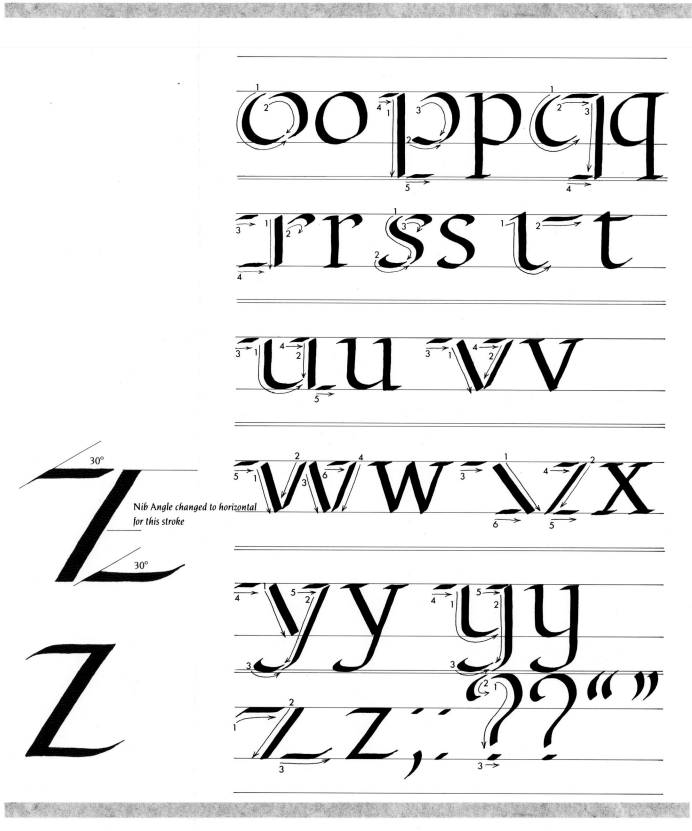

Nib Angle changed to horizontal
for this stroke

During the Renaissance there was a revival of interest in classical inscriptions, and a reintroduction of interest in the Carolingian minuscule of the ninth century. This produced a script based on those letters referred to as the Humanist minuscule.

a a b b c c
h h h h i i
o o p p q q
u u v v x x
g g ſp ſt œ ſt . :

Roman lower-case – Renaissance form

Giovan Francesco Cresci (*c* 1534–after 1600) was one of the most influential of the sixteenth-century Italian writing masters, producing a number of printed books reproducing his demonstrations of various alphabets. This is a woodcut interpretation of pen-drawn lower-case Roman letters, a good example of the styles current at the time when printers' types were being developed. As was common in copy-books, some letters are given in different constructions – 'h' is shown in two versions and 's' is demonstrated both as the now-familiar small letter and as the long character seen in medieval scripts. There are interesting forms in the double 'f', crossed and uncrossed, the double 'g', joined and lapping, and other examples of commonly used ligatures (joined letters).

The Roman letter continued to be a source of inspiration throughout the centuries and particularly so during the Renaissance in Italy. The classical proportions were retained, sometimes confined to mathematical construction. Serifs were sometimes squared and the letters achieved a heavier character. Cresci regretted that the woodblock-printed letterforms sometimes lacked the precision of his original pen forms.

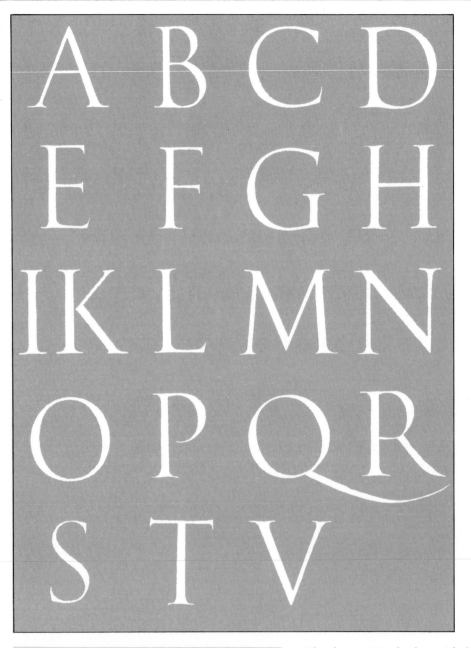

Roman capitals – Renaissance form

Another example from Cresci's woodcut-printed lettering samples shows a variation on the Roman capitals in which some of the characters are slightly narrowed when compared with the original classical forms; the letter strokes are typically weightier, the serifs flattened and heavy. Printed copy-books were devised as far as possible to reproduce the features of pen-written letters but the medium of woodcut does not lend itself entirely to the essential fluidity of the pen's movement.

Some of these letters appear to have a brush influence. The serifs are thickened, possibly because of the woodblock technique.

a b c d e f
g h i l m
n o p q
r s t u x
y z

Roman lower-case – Renaissance form

These lower-case letters have a solid overall consistency enlivened by deliberate variations in certain individual features of their design. The pattern of squared serifs at the bases of the letters and descending strokes is contrasted with the hooked terminals of 'a' and 'e' and the slightly curved strokes of 'b', 'd', 'h' and 'l'. The closed lower loop of the 'g' is a standard feature of lower-case Roman alphabets which survives in modern-day typefaces, compared with the usually open tail of the italic small 'g' when it is hand written.

Modified Roman capitals

This is a well-adapted modern interpretation of the standard form of Roman squared capitals, elegantly proportioned and with strong but fluid variations between the thick and thin pen strokes. The fine, subtly curving serifs form slightly extended terminals to the main strokes. The lettering has a lightweight, open feeling enhanced by the broken counters of 'P' and 'R', where the curving stroke forming the bowl of the letter does not quite reconnect with the main vertical stem. The numerals are carefully designed as a complement to the lettering, contained within a fixed height with no rising or descending strokes breaking through the lines. Numerals of this type are, of course, a replacement for the original system of Roman numerals constructed from the characters 'I', 'V', 'X', 'L', 'C', 'D', 'M'. The squared oval form of the nought neatly and logically distinguishes itself from the rounded capital 'O' of the alphabet – a distinction that all too few beginners initially appreciate.

ABCD
KLM
STU

1234

E F G H I J
N O P Q R
V W X Y Z

5 6 7 8 9 0

a b c d e f g h i j k l m n o p q r s t u v w x y z &

Again the brush seems to have had an influence in the forming of this light minuscule Roman alphabet.

Roman lower-case –
Modified minuscules

These fluid and well-proportioned letters represent a marriage between the pen-written minuscule letters of early medieval manuscripts and the upright, even style of lettering in classic Roman design. Modern calligraphy is characterized by a continuous reassessment of the evolution and development of alphabets. The combination of two or more styles can offer subtle variations in design which lead to a satisfying and lively reworking of traditional letterforms. The swelling curves and flowing verticals of these letters are enhanced by the use of fine hairline serifs and extended terminals. It is a modern version, but this style of lettering was also current in the eighteenth century, during a period of classical revival, and it was at that time common practice to describe the letters with a brush rather than a pen.

A B C D E G H
J K L M N P Q
R S U W X Y Z

ABCDE
GHJKLM
NPQRS
UWXYZ

Roman capitals –
Modern adaptation

This modified version of Roman capitals is adapted to the foundational style of calligraphy developed in the early twentieth century, when modern scribes carefully studied and reinterpreted the lettering of early pen-written manuscripts. While adhering to the formal proportions of the letters, the alphabet has been designed as if it were a text. 'L' and 'Y' have been presented in a smaller scale (above), to adjust the overall spacing of the four lines of lettering and produce a balanced texture throughout when used *en bloc*. The letters 'F', 'I', 'O', 'T' and 'V' have been omitted but these can easily be worked out by reference to other forms. The upper branches of the 'Y' form a broad, open angle while the inner strokes of 'W' are designed to cross rather than meet at the top of the letter, emphasizing it as a double 'V'.

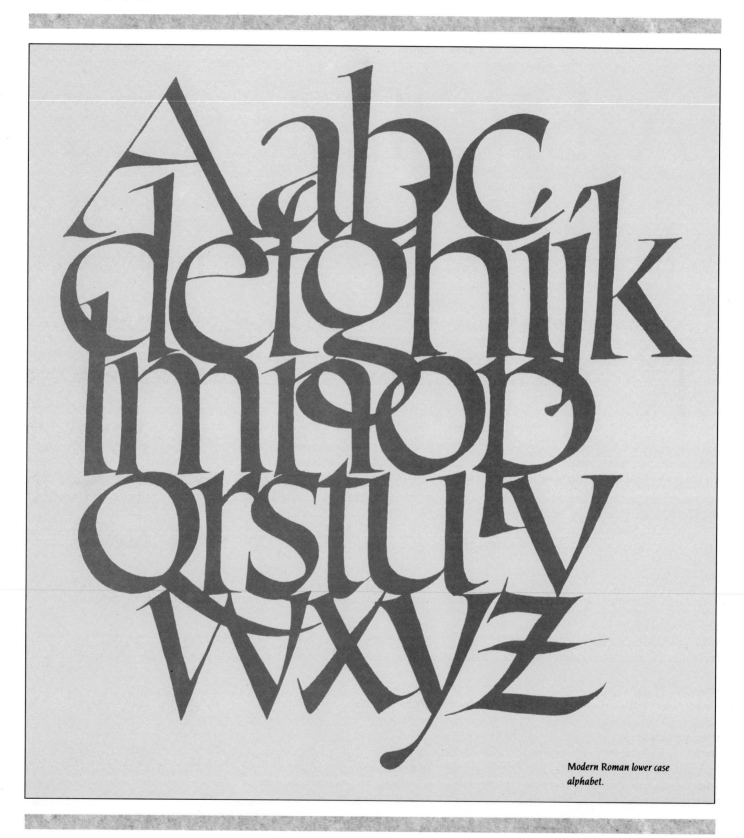

Modern Roman lower case
alphabet.

a b c d e f g h i j k l m n o p q r s t u v w x y z &

Modern Roman
lower-case

Here again, the alphabet is used to construct a densely textured pattern. Interlocking forms and crossed strokes develop the character of the design, but the intrinsic shapes of the individual letters are perfectly preserved. Particular features are introduced to fill and shape the overall design of the text. The 'f' is finely narrowed to fit between the rounded shapes of 'e' and 'g', while the capital form of 'Q' is used, adapted to lower-case proportions, so that the drawn-out tail travels broadly across the slanted strokes of 'w'. The central cross-stroke in the 'z' is a device often favoured by calligraphers to add extra horizontal emphasis to the letter, balancing the fineness of the right-to-left diag-

onal. This is a particular feature of northern European style, more commonly seen in Gothic alphabet forms.

Slanted Roman
lower-case

The distinctive slant of these letters refers to italic writing as do the oval counters of 'o', 'b', 'd', 'g', 'p' and 'q'. But there is a generosity in the width of the oval and the letterforms are devoid of the sharply arched and branching strokes which characterize a true italic. The flattened, horizontal serifs come from the basic style of the classical Roman lettering, but the slanting is emphasized by the drawn-out tails of 'j' and 'y' and the tight angle formed where the loop of the 'g' returns to the baseline.

Similar fine flourishes as in the two previous alphabets indicate the use of the brush in the formation of these slanted Romans. Note the terminals in 'j' and 'y'.

Alphabets: Uncials

Uncials followed the Roman square and Rustic capitals and were the result of the need to write in a formal style, but more quickly than is possible using the stately, deliberate capital forms. Uncials are bold, upright and rounded. They are natural pen letters, having simple constructions and finishing strokes, fluidly contained within the fixed angle of the pen and the direction of strokes.

The existence of two or three alternative constructions for more than half of the letters indicates that the uncial was an adaptable and highly practical hand. These variations all fit within the general family characteristics of uncials, but are an indication of how speed in writing tends to produce natural modifications of form.

Uncials were the standard book hand of scribes from the fifth to eight centuries, later superseded by the half-uncials and the rapid development of minuscule scripts. They were somewhat neglected during the revival of formal calligraphy; although Edward Johnston commended them as typical pen-made letters and adapted them for his own use, they were not promoted as enthusiastically as other forms of lettering such as italic and Johnston's own Foundational hand based on tenth-century script. More recently, uncials have found favour as a highly decorative and vigorous alternative to straightforward capital and lower-case forms. Despite their association with some of the finest early Christian manuscripts, they seem to have

a curiously modern flavour, which is well-suited to contemporary ideas of design.

Uncials are a straight-pen written form, where the pen is held with the edge of the nib parallel to the writing line. The thinnest strokes are precisely horizontal and the thickest vertical. Uncials are naturally quite heavily textured, although they are also pleasantly open as a result of their rounded constructions. The uncial 'O' is a round character, but because there is a pronounced thickening of the curves on either side, the pen form extends across the circular skeleton. The inner space follows the curve of a circle more closely than does the outline of the overall form.

Serifs occur as natural extensions of the pen strokes; on a vertical stem, for example, the serif is formed by pulling the pen from a leftward direction to form a line flowing easily into the broad stem. It can be squared off at the right-hand edge by drawing the pen down vertically over the original curve. The rounded version of 'W' has a serif extended both ways; this is made by a light stroke coming in from the left, crossed by a similar stroke from the right, which follows into the main curve. Since the edge of the pen is horizontal in forming these strokes, the evenness across the top of the serif is automatically established. In general, the curved and extended strokes of uncials have a naturally graceful finish owing to the rhythm of the pen's progress; tiny hairline 'tails' can be created by a quick twist of the nib before lifting the pen.

A regular, even-height script such as uncials can be used to good effect in a repetitive pattern. Here, basic uncials give a textured, woven look in a design for florist's wrapping paper.

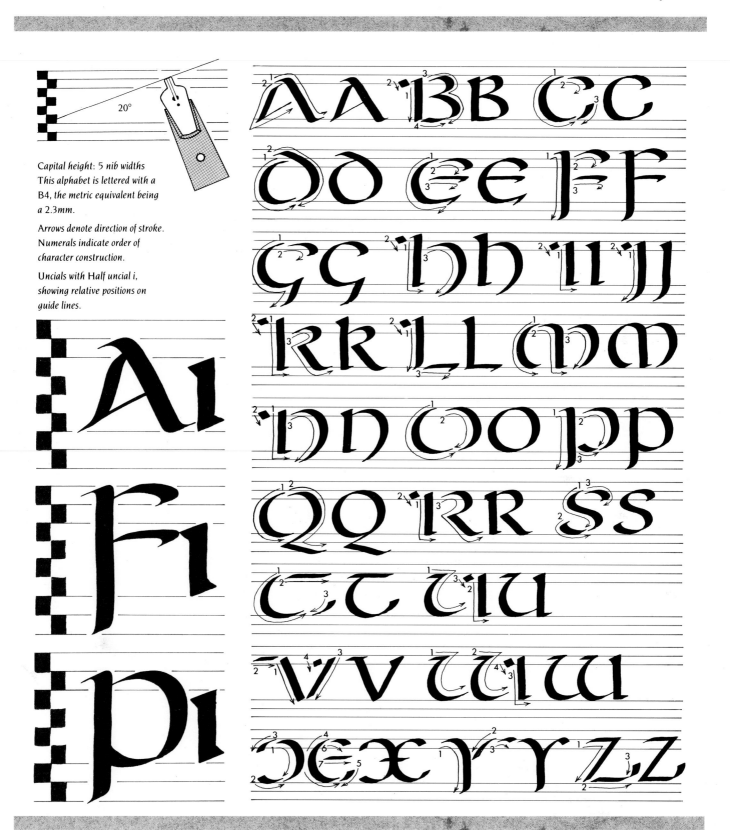

Capital height: 5 nib widths
This alphabet is lettered with a
B4, the metric equivalent being
a 2.3mm.

Arrows denote direction of stroke.
Numerals indicate order of
character construction.

Uncials with Half uncial i,
showing relative positions on
guide lines.

Lining numerals

Alternative capitals

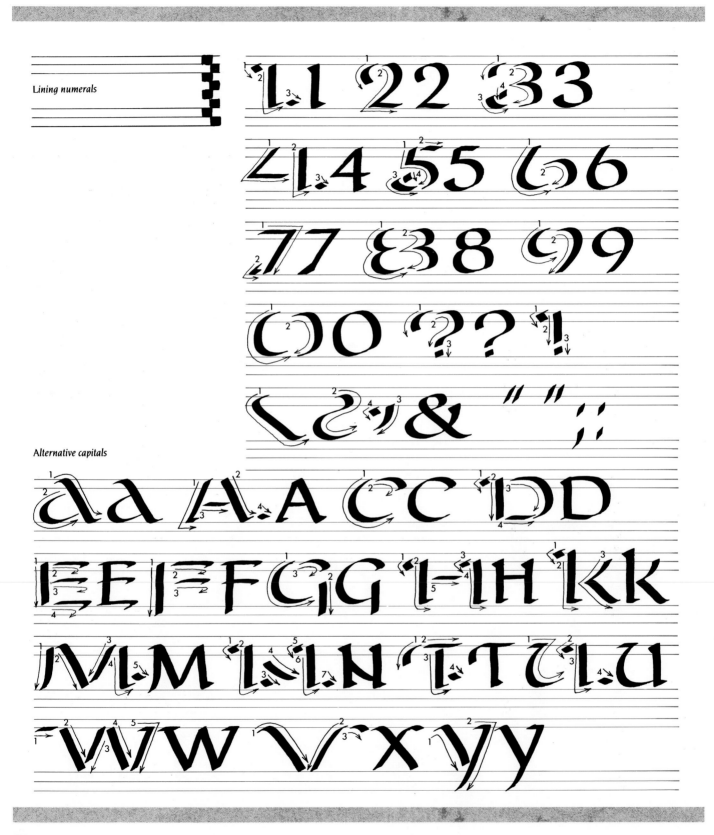

Ascenders: 2 nib widths

'x'-height: 4 nib widths

Descenders: 2 nib widths

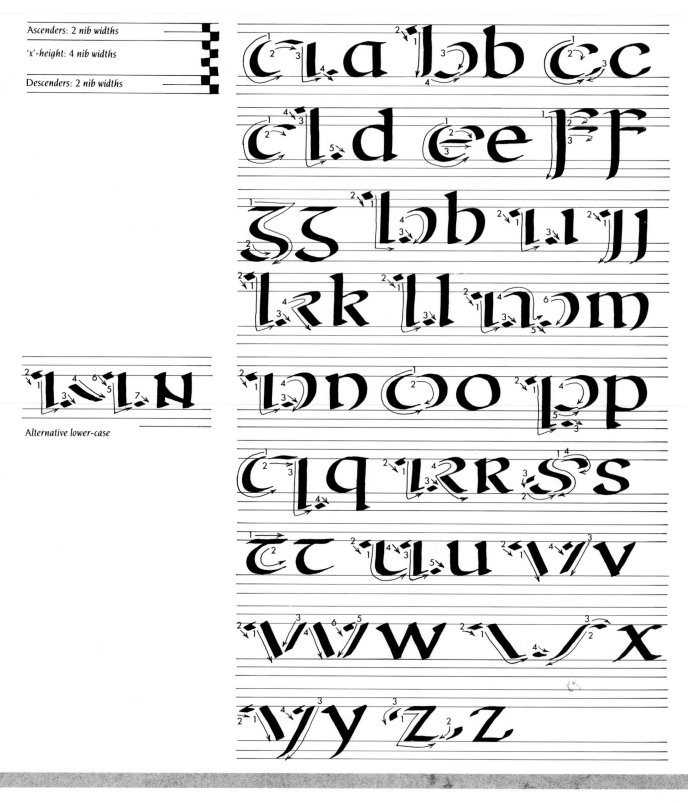

Alternative lower-case

ABCDEF

OPQRST

abcdef

opqrst

English uncials and half-uncials

This alphabet shows another modern transcription of the early uncial form, followed by a half-uncial alphabet, the book hand which followed on from uncials. In this case the half-uncials are based on early English lettering from the beautifully decorated Lindisfarne Gospels, written in the seventh century AD. In the half-uncials, the characteristics leading to minuscule, or lower-case, forms are readily apparent. This is a systematic and formal script, with deliberate ascenders and descenders breaking out of the body height of the letters. Despite the lingering reference to the capital form of 'N', this is otherwise the precursor of lower-case forms and it is particularly noticeable that the semi-captialized 'A' still in use in the uncial alphabet has been completely modified into the more rounded, compact character.

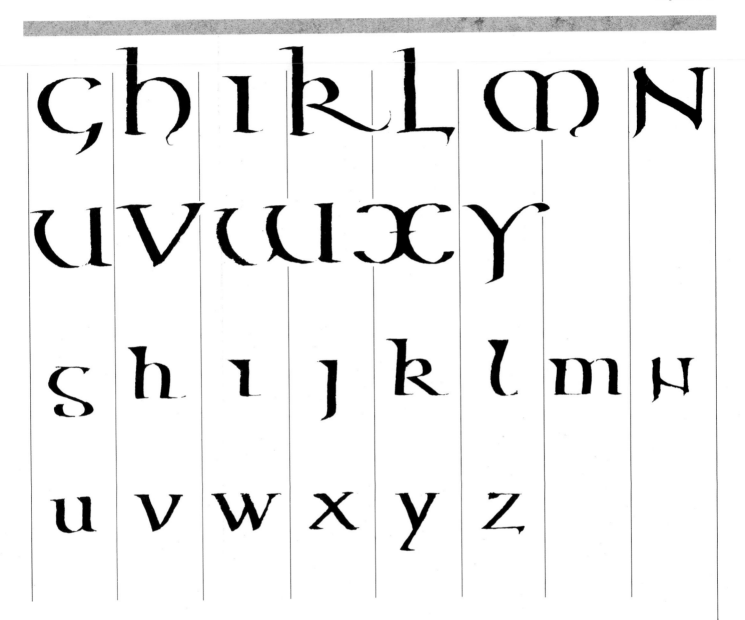

Alphabets: Modified 10th-century

The modification of tenth-century minuscule script produces a rounded, vigorous letterform, naturally adapted to the movements of hand and pen in calligraphy. There is both invention and adaptation in this alphabet, as in the curving forms of 'V' and 'W', and in the regular vertical emphasis of 'a' and 'g' in the minuscule form, which are sloping and more freely written in the earlier versions. In addition, the tenth-century manuscripts often show use of the long 's', which to modern eyes appears to be 'f'; in the modified hand the 's' conforms to the expected shape in relation to other letterforms. The alphabet of capital letters has been systematically constructed to accompany the modified script and is not typical of tenth-century capitals.

Like the Roman capitals, this hand has a regular system of proportion and a subtle graduation of thick and thin strokes, but it is open, broad and less severe than the square capitals. The pen angle used is 30°, as with the Roman capitals, which gives the tilted, circular 'O'. The lettering is quite sturdy and compact. The vertical and rounded forms are dominant, so in letters that have a vertical stem this is usually the first stroke written.

Serifs at the top of vertical strokes are simply formed by a slight curve starting the stroke from the left, and then overlaid with a vertical stroke to sharpen the right-hand edge. Less formally, in oblique strokes the fluid motion of the pen is allowed to begin and end the stroke in a logical manner – tails curve naturally with a tiny flourish as in the minuscule 'g', 'k' and 'y' and the capitals 'K', 'R' and 'X'. This script almost has the freedom of a cursive hand and the letters should be closely spaced so there is a lively horizontal linking between the forms, occurring easily through the characteristic rhythm and direction of the strokes.

This example (right) by Edward Johnston, demonstrates his Foundational hand, a modification of an English tenth-century hand that was a standard script for scribes. Johnston updated the old minuscule forms and the result is more upright letters accompanied by similarly modified capitals.

Dignus es Domine Deus noster, accipere gloriam, et honorem et virtutem quia tu creasti omnia, et propter voluntatem tuam erant, et creata sunt. And I saw in the right hand of him that sat on the throne a book written within and on the back, close sealed with seven seals. And I saw a strong angel proclaiming with a great voice, Who is worthy to open the book, and to loose the seals thereof? And no one in the heaven, or on

Above: The lower-case and capital letter alphabets of the modified tenth-century hand are written with a pen angle of 30°; the weight is four nib widths to height. The order of strokes is shown for each letter in the lower-case alphabet. A rounded, almost cursive hand, the letterforms should be written fairly close together.

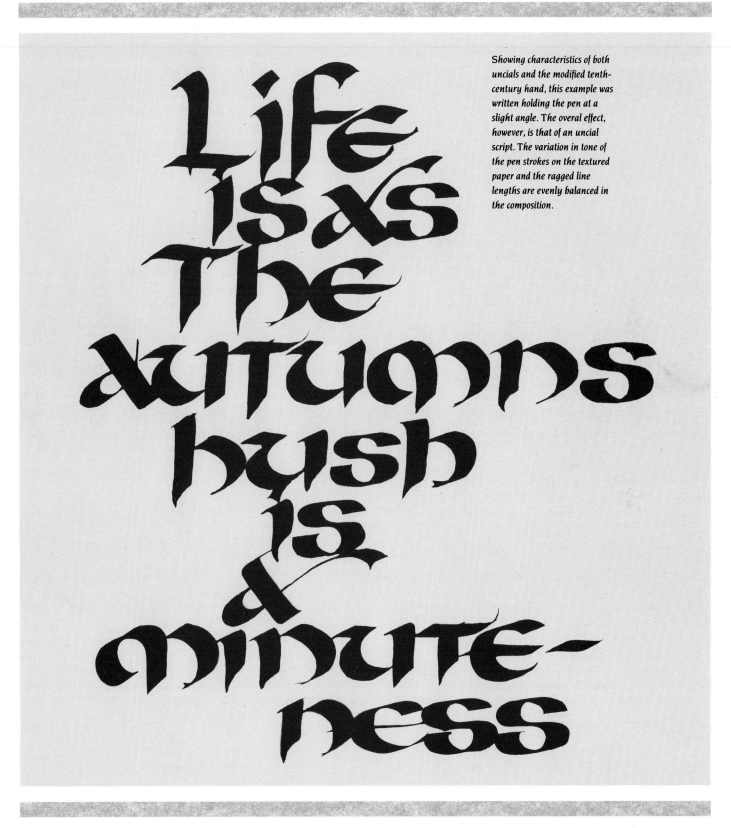

Life is as The autumns hush is a minute- ness

Showing characteristics of both uncials and the modified tenth-century hand, this example was written holding the pen at a slight angle. The overal effect, however, is that of an uncial script. The variation in tone of the pen strokes on the textured paper and the ragged line lengths are evenly balanced in the composition.

Alphabets: Black Letter, or Gothic

 Black Letter, Gothic or Old English as it is sometimes called, is a very condensed, upright style, elaborate and, in many examples, extremely difficult to read.

However, from the tenth to the fifteenth centuries it was the main style in use. It is difficult to imagine the reason for adopting this style in preference to uncial or half-uncial forms. To explain it there is one school of thought which maintains that the style was introduced as a space-saving measure. It is very economical in its use of paper because of its compactness. During the period that Black Letter was popular, there was a greater requirement for documentation and literature; so it follows that a style that required less space to convey a message would be preferred.

At its most formal, Gothic Black Letter could be written as a series of evenly spaced verticals, which might then be adapted to form any letter by the addition of oblique joining strokes, abbreviated cross-strokes and extensions ascending or descending from the body of the text. When it is presented in this type of systematic patterning, it is almost illegible to modern readers. However, it would seem that the vertical stress of Gothic lettering was widely accepted by its contemporary readers, since it formed the model for the early type of designs of the Gutenberg Press. It was in use for such a long period and in so many different places, that there are naturally a number of variations of Gothic letterforms which can be adapted to current use.

The nib angle is consistently 45° and at the beginning of each stroke there is a hairline serif. This is produced by moving the nib sideways at the lettering angle before changing direction to start the first thick stroke. The reverse is the case for a finishing hairline stroke. It should be noted that the direction of nib is changed three times to make the average lower-case stem with a movement towards the left, giving a slight rounding at the bottom-right side for a left-hand stroke, before finally changing direction to meet the base line.

The capitals are formed by multiple strokes. It will help students if the individual movements are traced, and the letterforms built up in this manner. This method will improve judgement of the amount of space to leave for the hairline and embellishing strokes, and assist in the accurate positioning of those strokes that join. The curious construction of X in this alphabet eliminates the usual crossing of two oblique strokes and subordinates the form to the consistency of vertical emphasis. The capitals should never be used on their own as the resulting patterns will be illegible.

The compactness of the alphabet means that, as with uncials, close letter- and word-spacing is required to produce an even texture.

Although Roman numerals were used in conjunction with Black Letter, I have included a set that I feel complements the style. There are many different examples of the form, a large proportion being fairly decorative.

This packaging design for cosmetics makes use of a modified version of Gothic script. The angularity of the writing makes it suitable for such graphic treatment.

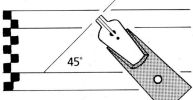

Capital height: 7 nib widths
This alphabet is lettered with a
B4, the metric equivalent being
a 2.3mm.

Nib Angle approximately 45°

Arrows denote direction of stroke.
Numerals indicate order of
character construction.

Use edge of nib for vertical
hairline strokes.

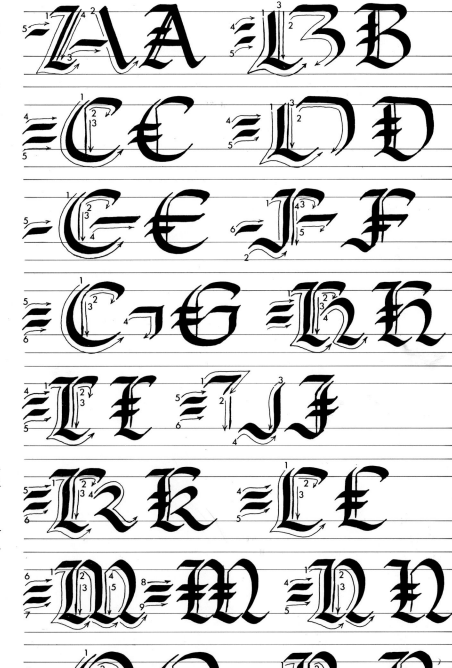

O Q Q R R

S S S T E

U U U V V

W W W

X X Y Y

Z Z & &

Lining numerals

1 1 2 2 3 3 4 4 5 5

6 6 7 7 8 8 9 9 0 0

Ascenders: 2 nib widths

'x height: 5 nib widths

Descenders: 2 nib widths

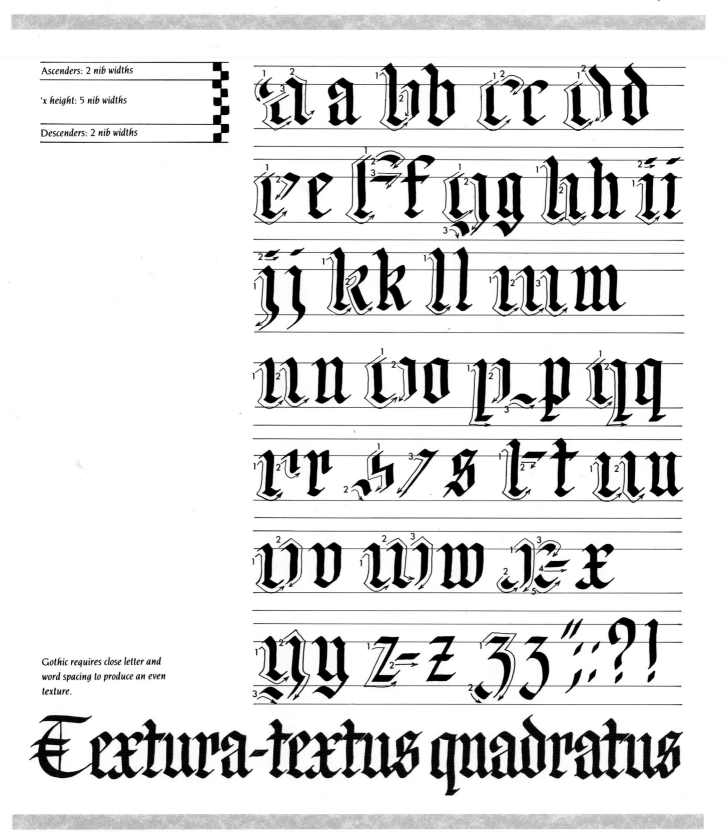

Gothic requires close letter and word spacing to produce an even texture.

Textura-textus quadratus

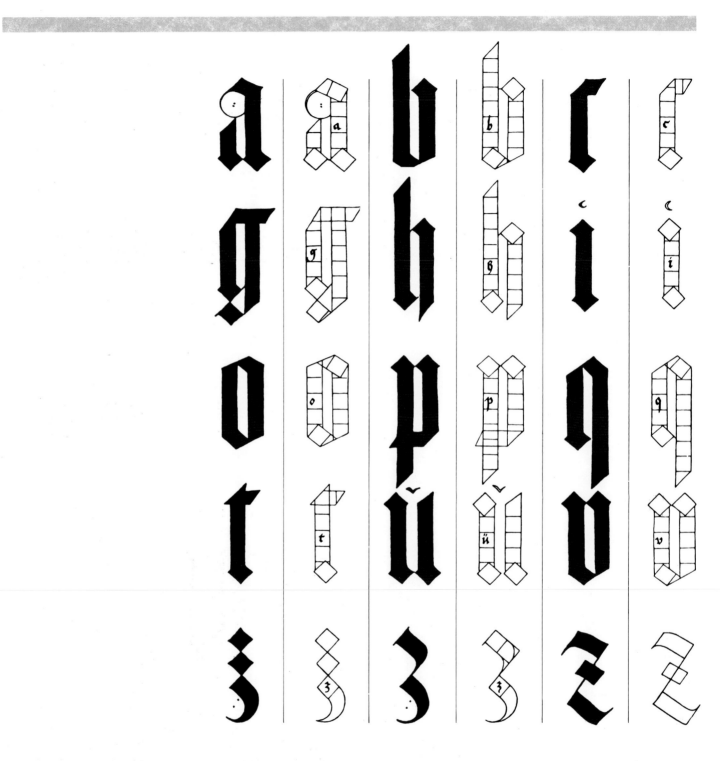

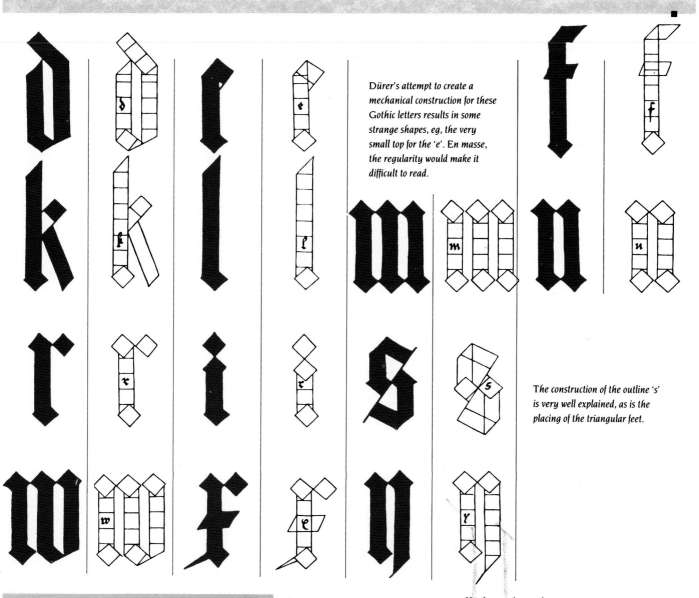

Dürer's attempt to create a mechanical construction for these Gothic letters results in some strange shapes, eg, the very small top for the 'e'. En masse, the regularity would make it difficult to read.

The construction of the outline 's' is very well explained, as is the placing of the triangular feet.

Simple Black Letter

These tall, narrow Gothic letters were constructed by the German artist Albrecht Dürer (1471–1528). The precision of form in his painting and drawing indicates the discipline of his working methods, here taken to a mathematical extreme in the strict proportioning of a Black Letter alphabet. The grid diagrams show how carefully and accurately each letter is worked out, the elongated vertical stresses giving rise to narrow counter spaces actually less than the width of the pen stroke. As usual in Gothic forms, the 's' has a complex construction required by angularizing of the double curve and this is more clearly defined by the linear diagram. The diagrammatic approach also demonstrates the placement of the lozenge-shaped serifs at top and bottom of the strokes. The narrowness, height and perfectly regular proportions give a pleasing character and consistency to the dense black lettering. The result, however, is not too legible.

Flourished Gothic

Another alphabet designed by Albrecht Dürer has a rather more loose and decorative character. Although narrowly proportioned like the previous example, it is more generous in the interior spaces and the curving flourishes relieve the methodical patterning of the basically vertical emphasis. A form typical of Gothic styling is the single stem of the small 'x' crossed by an emphatic horizontal bar, rather than the crossed diagonal strokes common to both earlier and later alphabet styles. The capital letters are more rounded and open than their lower-case counterparts, elaborated with the device of two or three lozenge-shaped ornaments. Dürer carried out many woodcuts and engravings as illustration for printed books, and his interest in letterforms may be seen as relating to both handwritten and mechanically printed texts.

This decorative alphabet has an intriguing, diamond-shaped pattern. Used separately, the letters have an even, modern look.

e f g h i k

p q r s t v x

a b c d e f

l m n o p q

u v w x y z

Alphabets: Italic

talic was the typical pen form of Renaissance Italy. It came into being in the interest of developing a greater writing speed while maintaining an elegant, finely proportioned form in pen script. The characteristics of italic are the elliptical 'O', on which model all the curved letters are constructed, the lateral compression and slight rightward slope of the writing, and the branching of arched strokes flowing rapidly out of the letter stems.

Italic is by nature a lightweight form and is usually written with a nib width narrower than those used for the rounded forms of medieval book hands. There is less variation in the widths of italic letters, but they are elongated, with extended ascenders and descenders. For this reason, the height should be carefully controlled to keep the pen strokes firm and cleanly curved. In keeping with the flowing elegance of italic, the tails, ascenders and descenders are often elaborately flourished or looped. For practical purposes, a simple, basic form is easier for the beginner.

It has an inclined angle to the right, which can vary from a few degrees to 13° from the vertical. After 13° the pen forms produced are not balanced, with straight and curved strokes differing greatly in weight.

Serifs in the capitals are formed either by a change of direction of stroke, or by an upward movement before and after the main strokes. Additionally, serifs are made by overlapping curved strokes over main strokes, such as in the 'B', where the beginning of the curved stroke which forms the upper bowl overlaps the left-hand edge of the main stem.

Lower-case serifs are produced in a similar fashion to those of the capitals. Ascenders and descenders can be finished with an extra flourished stroke, either straightish lines curving upwards or rounded strokes ending in a slight hook or merely sheared straight terminals. They extend one nib width above the capital line and three nib widths below the x line. They can be extended beyond these areas and flourishes, but with discretion.

Loops and tails are finished on the natural curve of the pen stroke. It is common to see ascending strokes carried over on a curve to the right, following the general emphasis of the lettering. This is a convenient way of tailing off the ascenders, but it is a matter of preference whether this style or a simple, pen-made serif is used.

Compression of the letterforms lessens the width differentiation between characters: the capital and lower-case 'M' are proportionally much narrower than their Roman counterparts when compared to, for example, the letter 'P'.

There are two kinds of numerals which accompany the style: lining numerals and hanging numerals. The former line up with the capitals, whereas the latter vary. The 1, 2 and 0 are contained within the x height; the 3, 4, 5, 7 and 9 enter the descender area to the value of two nib widths; the 6 and 8 are lettered to the height of the capitals.

Capital height: 7 nib widths
This alphabet is lettered with a
B4, the metric equivalent being
a 2.3mm.

Nib Angle approximately 45°

Arrows denote direction of stroke.
Numerals indicate order of
character construction.

Flourishing should not be at the
expense of legibility.

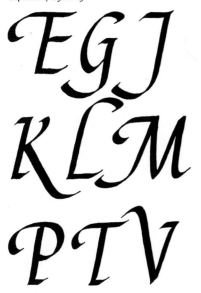

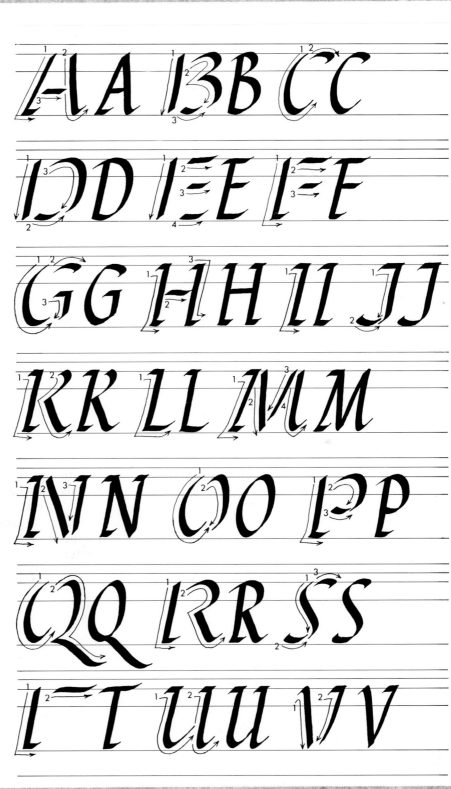

W W W W X

Y Y Y Z Z

Z & & & ? ? ! !

Lining numerals

1 1 2 2 3 3 4 4

5 5 6 6 7 7

8 8 9 9 0 0

Hanging numerals

1 2 3 4 5 6 7 8 9 0

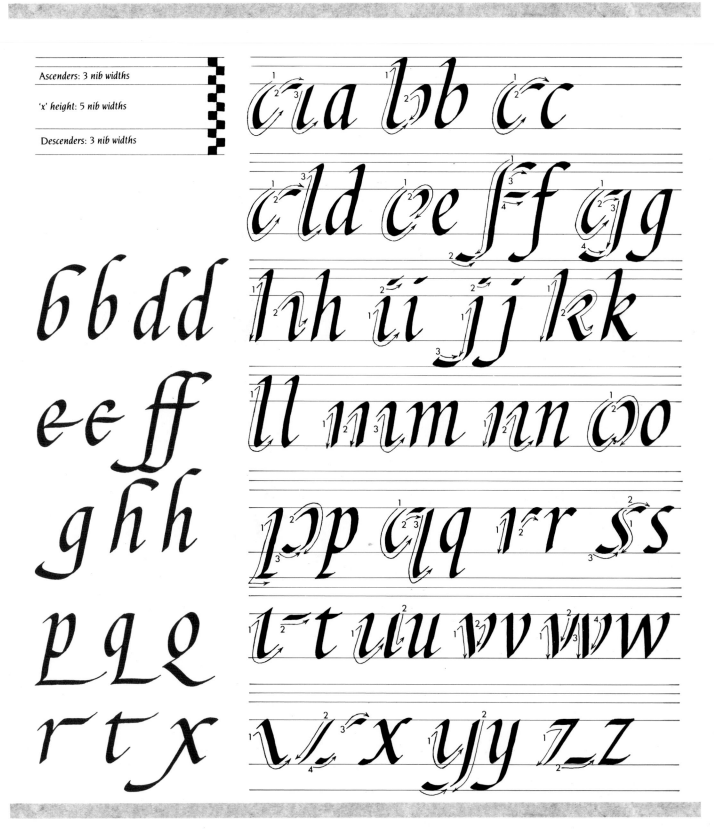

Ascenders: 3 nib widths

'x' height: 5 nib widths

Descenders: 3 nib widths

a b c d e f
g h i j k l
m n o p q
r s t u
v w y y z

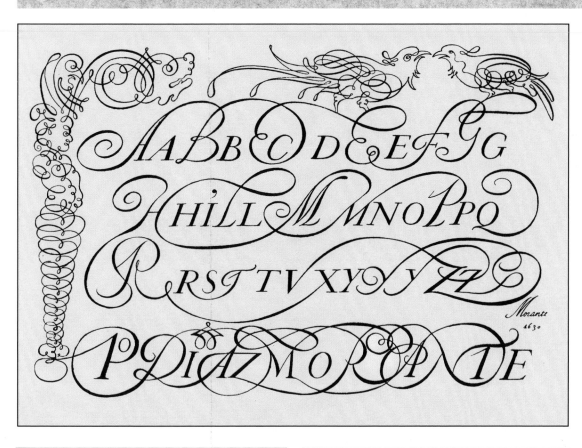

An interesting contrast between the simple, slanted Roman and the flowing, near copperplate capitals, both artfully intertwined in this design.

Fine italic

The delicate weight and texture of this italic sample derives not only from the finer pen line but also from the more generous width and openness in the letters by comparison with the previous compressed, cursive example. The oblique angle of italic is very subtly expressed here, mainly visible in the tall, curving ascenders. The fineness of the line where the bowls and arches branch from the main stems contributes to the restrained elegance of the form. The flow of the lettering is emphasized by hairline hooked serifs leading into and out of the stems and slanted strokes. The alphabet is a good illustration of how the writing tool imposes a distinctive style on the lettering and, by comparison with the heavier italics, shows the different moods given to similar basic structures by the density of the written texture.

Flourished italic

A decorative italic alphabet by Spanish calligrapher Pedro Diaz Morante (b 1565) shows the coming influence of copperplate style, its controlled loops and arabesques anticipating the more excessive linear ornamentation that in later samples almost overwhelmed the written forms. Two alphabets are woven together here to create the overall design. The most readily legible consists of a broadened italic form still influenced by the thick/thin variation of the edged pen, though the natural pen stroke is modified and the letter stems vary in width. This is framed and embellished by freely written alternative forms of the letters with flourishes flowing back and forth to create a curvilinear framework in which the italic letters are squarely presented. Diaz Morante was a highly influential writing master.

A B C D E F

N O P Q R S

a b c d e f

o p q r s t

1 2 3 4 5 6 7 8 9 0

G H I I J K L M
T U V W X Y Z
g h i j k l m n
u v w x y z

Decorative
humanistic italic

In the lower-case sample, this alphabet follows the features of a classic italic style, but it is in the capital alphabet that the particular characteristics of the designed form come into their own. The crossed strokes and evenly looped flourishes create a delightful pattern quality, though the letterforms remain distinct and fully functional within this decorative embroidery of the basic shapes. A discreet undulation travels through the assembled forms due to the dropped and extended strokes varying the height and depth of the letters. The movement of the pen through the thick and thin modulations in the stroke endows the basically lightweight forms with a subtle solidity, emphasized in the capitals because the rounded letters are broad and open. However, a sentence written in capitals might be difficult to read.

These capital and lower-case letters are based on a humanistic script of the sixteenth century. They have a delicate flow.

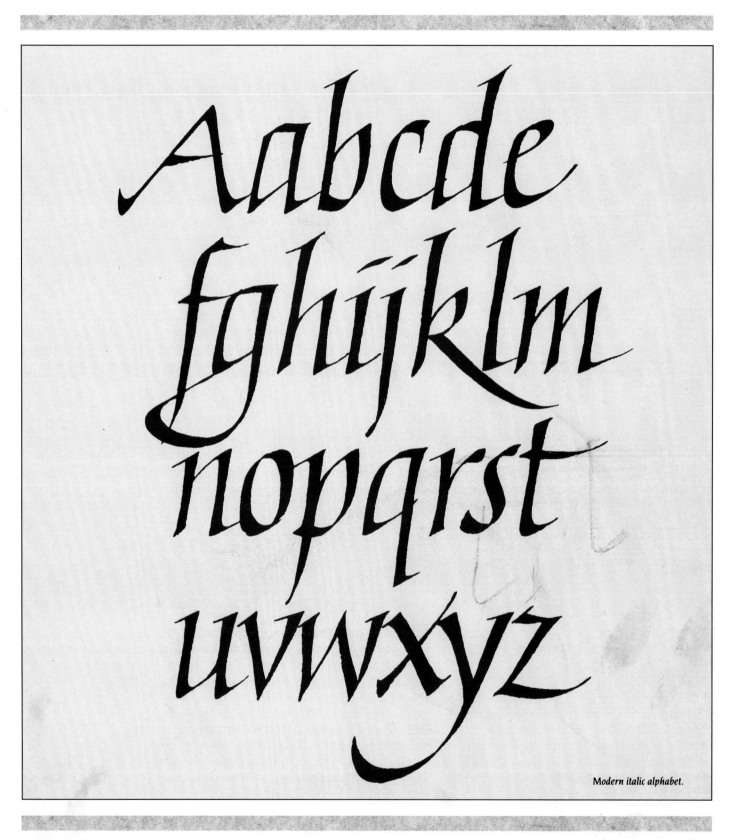

Modern italic alphabet.

abcdeefghij

klmnopqrsst

uvwxyzz

Modern italic alphabet

Based on sixteenth-century italic forms, such modern revisions make the most of the sharply branched and tightly compressed patterning of a cursive italic.

In this example, the sharpening of the letters suggests that edges and angles have been modified after the initial stroke to describe the particular texture of the finely slanted serifs and filled angles. This is apparent in the width variations in the bowls of 'd', 'g' and 'q', where the slight inner curve into the hairline is balanced by a sharp point pushing outwards at the base.

The angle at which the pen is held is sharper, too, than in many examples of italic alphabet shown in this book.

Formal italic

This is controlled and stately lettering, but not well adapted to a rapid or cursive writing method. Even between the different versions of the letters, it is the fluid control of the pen movement that supplies the consistency of texture, the elegance of the line variations and the aptness of the terminals. The letters with upright, serifed stems have a more static quality than those with finely tipped curving ascenders. Unusually, this device is applied also to the alternative versions of the letter 'P', so that while one of the forms is conventional in style, the other is extended and flowing, equally balanced above and below the body height of the letter. The sharply angled oval in the bowls of certain letters gives them an upward pull countering the relatively extended width.

Alphabets: Versals

Versals were used in early manuscripts as initial letters highlighting the beginnings of passages or important places in the text. Gradually they became more decorative and elaborate; in some cases, like these ninth-century 'zoomorphic' letters (right) the basic form is only barely discernible. Less fanciful versals were still used elsewhere in the text but initial capitals were freely interpreted representations of animal and plant life, vividly drawn and boldly coloured.

Versal letters are large or small capitals that are used to denote the opening of a chapter, paragraph or verse (hence the name versals), and to mark important passages in the text. In early manuscripts versals were simple forms based on Roman capitals. In Italy, there later developed a more exaggerated, bulging form often referred to as Lombardic, after the region where this style was first introduced into hand-lettered manuscripts. These Lombardic versals had their roots in the rounded forms of uncial letters, which can be seen in the curving shapes of 'E', 'H', 'G' and 'M'. Versal letters were the basis of the compound forms in highly decorated medieval manuscripts, which were also often adorned with figures, animals and plant forms, and richly ornamented with gold and bright colours.

Versals differ from the alphabet styles so far discussed, because they are built-up letters. While still dependent upon the pen stroke for their basic character, it is not a single stroke that forms the shape and thick/thin contrast. The stems of versal letters are formed from two outer strokes which are quickly filled with a central stroke. They are drawn, rather than written. It is usual to make the outer, left-hand stroke first, then the inner and flood in the central stroke immediately. However, when forming curved letters, the inside is the first stroke to be formed.

There are a few practical points of technique to note in relation to versal letters. The board

used as a support for the work should be lowered to a shallow angle. The width of nib used should be slightly narrower than that applied to the main body of the text. A quill is often used, with a slit lengthened to ½–¾in (1.2–1.9cm) long, which allows the paint, watercolour or gouache that has been diluted to a rich, milky consistency, to flow smoothly through the nib.

This versal alphabet (left) is in the Lombardic style, a curved, more exaggerated form based on uncials. Cross-strokes and serifs in both types of versals are wedge-shaped; the Lombardic versals, in particular, are often finished or flourished with fine hairline strokes.

Unlike calligraphic scripts, versals are built-up letters; their shape is not determined by a single pen stroke. Instead, inner and outer strokes are drawn and then the centre is flooded in a single stroke. This alphabet (lower left) shows both the skeleton form and some filled letters.

The quill is held perpendicular to the writing line as the main outline strokes are drawn and filled, but horizontally when applying cross-strokes, serifs and hairlines. The cross-strokes start at the width of the nib and are splayed in two flaring strokes at the end to produce the wedge shape. Hairline strokes form a clean right-angle to the main stroke and are not moulded into curves as in the classical Roman capitals. The curves of bowed versals are exaggerated slightly; the inner curve may be flattened and the outer curve made more pronounced. Once the outlines of a stem are drawn the centre should be flooded with the third stroke immediately, laying down enough paint to give a delicately raised effect when dry.

Versal letters should be built up quickly and spontaneously. Attempts to repair or modify the forms after they are fully written are likely to spoil the smooth curves and fluid, raised strokes. Exaggeration of bowed forms can be subtle or extreme, as preferred, but it is important to preserve clean interior shapes and to define the overall character of the letter distinctly. If versal letters are written very large, the proportions can be adjusted so that they are more elongated and refined as the height increases, otherwise the shapes become extremely bulky and will tend to overpower other writing on the page.

Versal letters in a body of text may be written in the margin, set into the text or positioned symmetrically on a line between the two. Traditionally, built-up letters are added after the general text is completed. If the versals are set within the text the necessary space must be calculated beforehand and the opening lines of text adjusted to accommodate them. Where versals fall in a vertical line down the margin, especially if they occur on every line or almost as frequently, they provide a more rational arrangement if they are centred on a vertical axis rather than aligned from one side or another. Otherwise the different widths of the letters can create a jumbled or apparently random design.

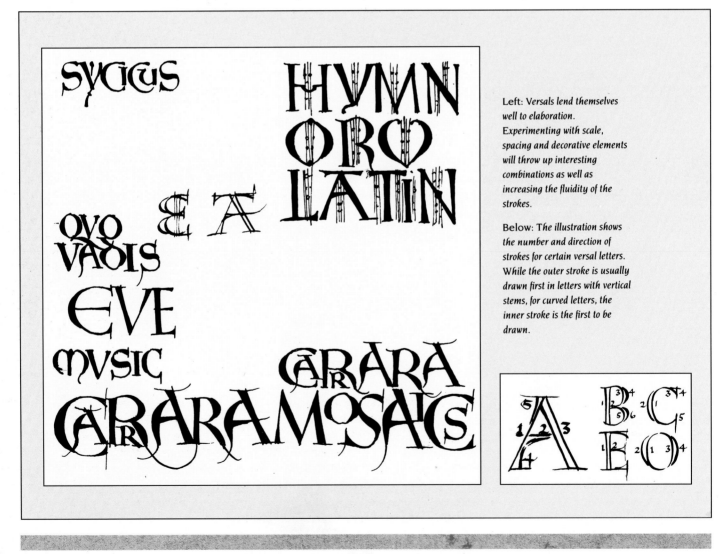

Left: Versals lend themselves well to elaboration. Experimenting with scale, spacing and decorative elements will throw up interesting combinations as well as increasing the fluidity of the strokes.

Below: The illustration shows the number and direction of strokes for certain versal letters. While the outer stroke is usually drawn first in letters with vertical stems, for curved letters, the inner stroke is the first to be drawn.

Ornamented versals

The weighty shapes of these Lombardic-style versals are sufficiently broad to allow a decorative piercing of the curves and stems, in addition to flourished and ornamental detail. The drawn versal letter can be the basis of a heavily ornamented or illuminated capital letter, decorated with abstract motifs or, as in the original miniatures of medieval manuscripts, with tiny pictures or figurative images. Colours can be introduced to add variety to the design and versals are also traditionally the subjects for gilding.

Effective layout

inn

INN

Straight letters – wide spaced

There are various conventions relating to the design of calligraphy that have developed in practice and are sound basic guidelines. In many respects, there are exact parallels between calligraphic and typographic conventions. In so far as these represent knowledge acquired by lettering designers of all basic disciplines and provide information on the advantages and drawbacks of different methods, they are valuable signposts for effective design. But all design rests to some extent on optical modifications and visual judgements that cannot be subject to measuring systems or reduced to infallible codes. No one device will apply to every situation, nor will it perform the same function in different contexts. The dual purpose of design in calligraphy is to make something interesting and pleasing to the viewer and by doing so, demonstrate a synthesis of visual and verbal qualities. The calligrapher will only learn through individual experiment and discovery. Good design is a matter of informed decision making, but it can also result from having the courage to break all the rules.

Letter spacing

Once the student has lettered his first alphabet, it is necessary to consider spacing the letters in order to produce words. This would be an easy task if all the character shapes were either

boo

BOO

Round letters – close spaced

reef

REEF

Open letters – fairly close spaced

avail

AVAIL

Oblique letters – close but variable

straight-sided or round, as then the same amount of space could be left between them. Unfortunately, the alphabet consists of many different-shaped characters; measuring the same amount of space between characters does not produce an aesthetically pleasing word. Instead reliance must be placed on optical spacing and fine adjustments.

Letter spacing is one of the most difficult aspects of lettering. Calligraphy, sign-writing, using pre-cut letters or lettering proper (that is, with a brush on paper or board), all these forms of communication require good letter spacing if they are to achieve their aim of informing in a legible and attractive manner.

The characters of the alphabet can be divided into four main groups: straight-sided, rounded, open and oblique. Some fall into more than one group; for instance, the capital and lower-case 'C' are both rounded and open. As a guideline, think of round letters as being close-spaced and straight-sided letters as being the widest spread. Consider these two groups. A vertical letter in its simplest form is the 'I' and a round letter the 'O'. If the combinations of IOOI and OIIO are looked at, the difference in spacing, can be seen. The first line lettered is spaced mathematically, the second optically. The difference is that optical spacing takes into account the nature of the 'O', with its round shape giving a greater amount of white area than a straight-sided letter. It is this counter-space which must be considered. The golden rule is not only to appreciate the shape of the letters but also the white areas that they create around them. These are just as important as the forms themselves, and the student cannot commit himself to a letterform without being concerned with the areas they create.

The aim of the letterer is to produce even areas of space between the letterforms. This will take time to learn, and experience only comes through a rational approach to spacing. A letterform's space requirement must be evaluated before committing pen to paper in order to achieve harmony.

Once the student has lettered his first two characters, he has set the criteria which will

IOOI OIIO
IOOI OIIO
INDOORS
INDOORS
DOODLING
DOODLING

determine the spacing of all the letters that follow. If the first two characters are straight-sided, they should be lettered with sufficient space between them to accommodate the close spacing necessary for round letters which may follow. Without making this judgement prior to lettering, the rounded forms will be tightly spaced and may even touch each other if the first letters are very close. The reverse can be said for two rounded characters at the beginning of a word. If they are spaced too far apart, the end result will be an over-spaced word because the straight letters will require extra space to appear optically balanced.

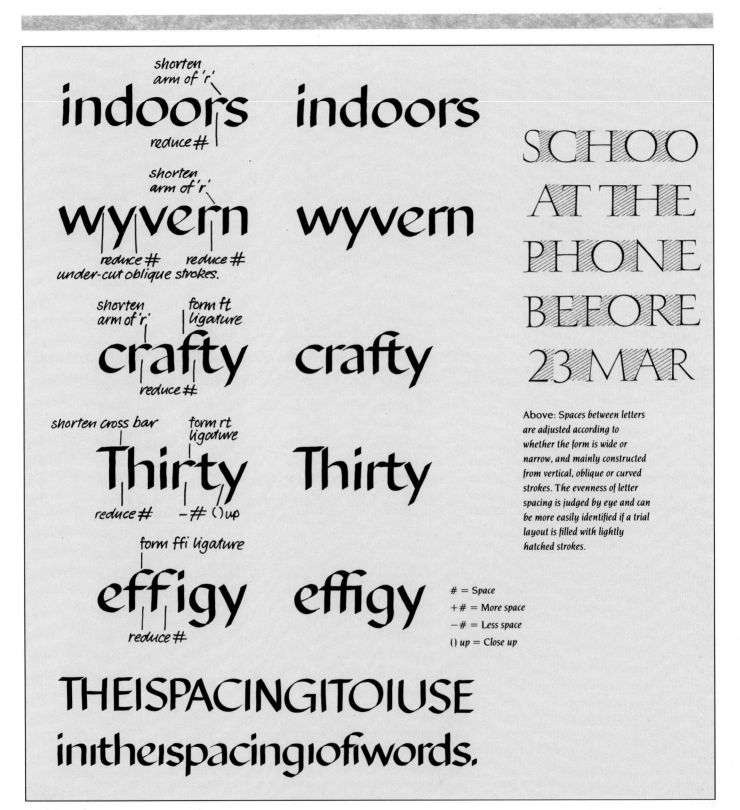

shorten arm of 'r'

indoors

reduce #

indoors

shorten arm of 'r'

wyvern

reduce # reduce #
under-cut oblique strokes.

wyvern

shorten arm of 'r' form ft ligature

crafty

reduce #

crafty

shorten cross bar form rt ligature

Thirty

reduce # – # () up

Thirty

form ffi ligature

effigy

reduce #

effigy

SCHOO
AT THE
PHONE
BEFORE
23 MAR

Above: Spaces between letters are adjusted according to whether the form is wide or narrow, and mainly constructed from vertical, oblique or curved strokes. The evenness of letter spacing is judged by eye and can be more easily identified if a trial layout is filled with lightly hatched strokes.

= Space
+ # = More space
– # = Less space
() up = Close up

THEISPACINGITOIUSE
initheispacingiofiwords.

Word spacing

The extension from a single word to a line of text requires word spacing, that is, the amount of space left between one word and another. Spacing is a prime determinant of legibility in a text. Some early manuscripts have no spacing between words; examples of this solid linear arrangement can be seen in manuscripts of square and Rustic capitals. In later examples the words are differentiated not by spaces, but by a small dot or stroke between letters, indicating the end of one word and the beginning of the next. By the tenth century distinct separation of words was standard form. Modern reading habits have been determined by a number of these inherited conventions, which have developed over hundreds of years.

Word spacing is strongly linked with letter spacing in that if too much space is left between words the rhythm of the line is broken, leading to poor readability. The amount of space used must be consistent if continuity is to be achieved. Therefore, it is necessary to have a unit of space which is regular throughout the line and a simple system to determine the amount of white to be left.

Again, there is no mathematical answer for achieving even units of space, as the letterforms differ in shape and optically vary in counter areas. Word spacing must therefore also be based on visual judgement; one system uses a capital 'I' for space between words in capitals and a lower-case 'i' for lower-case words. These 'i's are letter spaced between the words to give the same optical value. In effect, a complete spacing system has now been outlined.

The words in a line of text should be treated as a complete word. In the example, a capital 'I' has been inserted between the words and highlighted in red to illustrate the system. When a line of text is word-spaced, the 'I' should be lettered using a carpenter's pencil which has been sharpened to a chisel edge the width of the pen nib, simulating the pen stroke width. After a line is completed, erase the pencil to give the finished result. Once the student has

become familiar with word spacing, he need no longer use the pencil.

Draw up guide lines on a layout sheet using the proportions for Roman Sans Serif. Letter the example using the above method and compare the results with the sample lettered here.

When lettering more than one line of text it sometimes becomes necessary to add extra space between lines. This is known as interlinear space. The main reason for this additional space is to prevent the descenders of one line from clashing with the ascenders of the line below. Even half a nib width of space inserted between the lines can eliminate the problem.

The style of lettering used will affect the amount of space required. If the style has a large x-height with small ascenders and descenders, it will need more interlinear space than a style that has a small x-height with long ascenders and descenders. This is because the latter creates more open space between lines of text owing to its larger ascenders and descenders, and thus requires minimal interlinear space – if any – provided, of course, that characters do not clash. In some instances, it may be possible to reduce the length of ascenders and descenders to avoid clashing, but this should be treated with caution where letterforms with short ascenders and descenders are concerned.

Calligraphers may then apply aesthetic preferences for one page arrangement compared to another. A freely written, flamboyant word or phrase may seem more expansive and rhythmic if generously surrounded by white space, whereas small, fine writing in an open letterform may gain cohesiveness if allowed to create a mass of text that is both broad and deep across the page area. Alignment is an important factor.

wordnspacing
isnannessential
element.

Another standard for spacing between words written in a lower-case form is the width of the letter 'n'. For capitals the equivalent guide is the width of 'O'

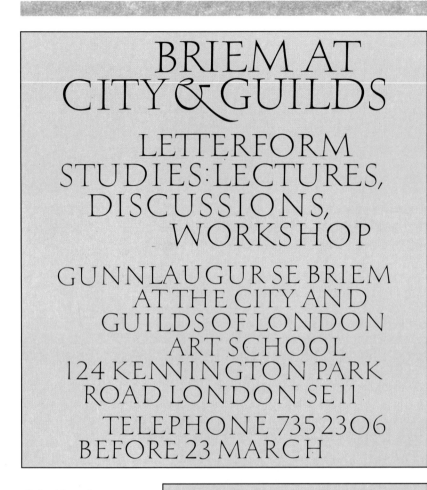

BRIEM AT
CITY & GUILDS

LETTERFORM
STUDIES: LECTURES,
DISCUSSIONS,
WORKSHOP

GUNNLAUGUR SE BRIEM
AT THE CITY AND
GUILDS OF LONDON
ART SCHOOL
124 KENNINGTON PARK
ROAD LONDON SE11

TELEPHONE 735 2306
BEFORE 23 MARCH

This hand-lettered poster (above) has a most unorthodox layout, since there is virtually no vertical alignment of the successive lines. The smaller version (right) has been arranged to show how it would look if centred on a vertical axis. In the original there is no such anchor; each line is shifted to left or right of the centre, giving a more spacious and lively arrangement, which works effectively because a standard letterform is used throughout and the proportions and letter spaces are extremely well balanced.

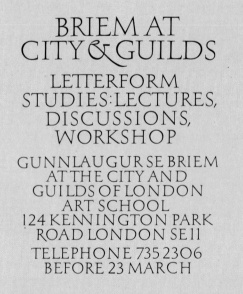

BRIEM AT
CITY & GUILDS

LETTERFORM
STUDIES: LECTURES,
DISCUSSIONS,
WORKSHOP

GUNNLAUGUR SE BRIEM
AT THE CITY AND
GUILDS OF LONDON
ART SCHOOL
124 KENNINGTON PARK
ROAD LONDON SE11

TELEPHONE 735 2306
BEFORE 23 MARCH

There are five main types of layout generally used, although there are always artistic variations and combinations. These can be grouped as: ranged left; centred; ranged right; justified; and asymmetrical.

RANGED-LEFT LAYOUT

Here the text is lettered flush to a left-hand margin, leaving the right-hand side ragged, that is to say the line lengths fluctuate. This layout is now used for all manner of work from quotations and poems to posters and invitations, and even manuscripts. The lettering in this type of layout is unforced, with word spacing of an even nature, and, because the wording for each line starts at the same position, it is relatively easy to produce. We are all conditioned from an early age to align text to a left-hand margin.

CENTRED LAYOUT

This is probably regarded as the classic way in which to display text, from invitations to fairly lengthy works. This symmetrical method of layout is both dignified and enduring and almost gives the work a stamp of approval. Any time a student is in doubt about the way in which a layout should appear, he should centre it.. Few people will comment adversely on a well-balanced piece of work: it projects harmony and not discord. To produce a centred layout requires both accuracy and patience because the individual lines of text must be lettered twice – once on a rough layout to establish a line length and discover where breaks in the copy occur, and then again for the final work. The necessary procedures will be discussed in more detail later on in this section.

RANGED-RIGHT LAYOUT

This layout is not chosen very often but can be effective on posters. It is usually used in conjunction with other graphic elements, where the text ranges with a drawing, photograph or similar device. Because the text is aligned vertically on the right-hand side, it is diffuclt to produce.

A decorated Italian fourteenth-century missal (left) shows a typical use of versal letters, set half in the margin, marking each new paragraph on the page. By contrast, the form of a ninth-century page of minuscule script (far left) is a plain and evenly spaced block of text, introduced by a large but undecorated versal 'B'.

The ending of each line must be accurate if the text is to align. As with centred layouts, the lettering must be written initially on a rough layout.

JUSTIFIED LAYOUT

A justified layout, or squared-up text, has to be the most arduous layout of all to produce. It requires accuracy at both the left- and right-hand margins, although justified text is more easily managed in a wide measure (the width of a column or line length) than in a narrow one. The letterforms and word spacing in each line have to be altered slightly to fit the measure. Because the line length is so short in a narrow column, each line has to be condensed or expanded in order to achieve a squared-up alignment on the left- and right-hand sides, sometimes resulting in drastic action. In order to produce the layouts, each line should be lettered several times before the correct width of character and spacing is arrived at. This is not a layout for the beginner, but is essential for some manuscript work if a book-like quality is needed. The main consideration when producing justified work is that of line length. Aim for at least seven to eight words on each line, which will make the task easier.

ASYMMETRICAL LAYOUT

This is used quite often in the name of artistic licence. I have seen some stunning examples of non-aligning text, but I feel that its use is limited and it should only be employed with caution. It is difficult to give rules on how to produce such a layout because so much is dependent on an individual's feel for balance and shape.

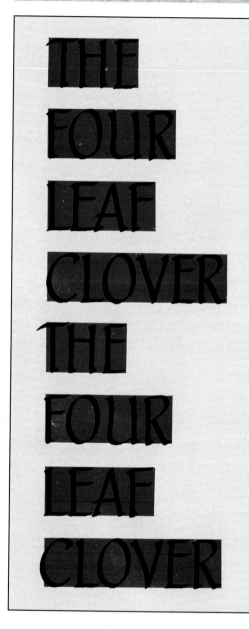

THE
FOUR
LEAF
CLOVER
WILL
BREAK
A FAIRY
SPELL.

THE
FOUR
LEAF
CLOVER
WILL
BREAK
A FAIRY
SPELL.

The red boxes in the first four lines are ranged left. The result can be seen in the second column. Some of the words appear to be out of vertical alignment. The second four lines have been optically adjusted to compensate for individual letter shapes. The result is good vertical alignment, as in column three.

Vertical alignment

When ranging left, ranging right or justifying text, consider the vertical alignment of the letterforms. Because the alphabet is made up of varying shapes – round, oblique and straight – adjustments must be made in order that one letter will appear aligned above another.

As a general rule, straight letterforms can be aligned with the margin line, while round and oblique forms will venture over the line. The capitals 'J' and 'T' will require the most movement for ranging left, as their arms project the furthest from the main stems; they are quite difficult to range optically. Practise with display sizes: large letterforms accentuate the movement involved.

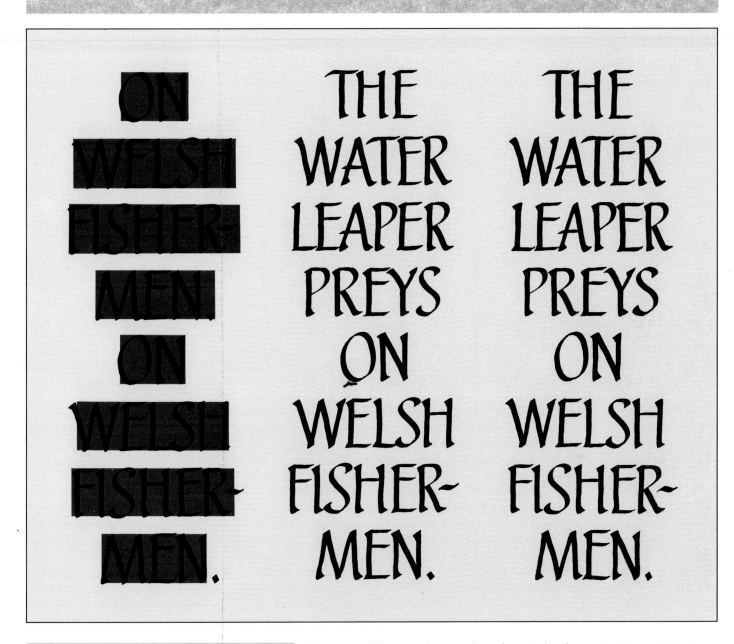

For centring display lines, especially where a narrow measure is used, it is best to place the word within a box, which should take up the visual length of the word. As with ranged-left alignment, round and oblique or open letter-forms would protrude over the edges. Take the world WELSH in the optically centred example: the 'W' will venture outside the box, whereas the 'H' will be contained. This optical width of word can now be measured, and the point at half its length positioned in the layout format on the centre line. For punctuation and hyphens, space must be added until the visual line has been decided upon.

The red boxes in the first four lines indicate the true length of the word and have been centred in the second column accordingly. The second four words have been placed in boxes of optical length, the result of which can be seen in column three.

Verso Double page spread Recto

Head – 1 unit Head

Measure – 8 units
maximum line length

Unit value – width of page
divided by ten.

Spine or Inner margin – 1 unit

Spine or Inner margin

maximum depth of text

Foredge – 1 unit

Foredge

2 Foot – 1.5 units
.75 of a unit

Foot Folio line ____ 3 ____

The text area

There are traditional margin proportions which have been used for many years in the laying out of single sheets and double-page spreads. The unit values of head, foredge, foot and inner (or spine) margins were based on proportions of the quarto and octavo folds of given sheet sizes. In the UK, a full-size sheet of any size is called a Broadside; a Broadside folded in half is called a Folio; a Folio folded in half, making four sheets, is called Quarto and a Quarto folded in half, making eight leaves, is called an Octavo. Sheets of approximately the same sizes are available internationally. Today, paper sizes have been rationalized, which eliminates the problem of recalling dimensions when given a name of a sheet size and then having to work out the set margins.

When deciding on the size of sheet to use for a specific project, and the layout and margins to be used, the amount of text and the nature of the work must be taken into account. This section is devoted to continuous text and the margin proportions and width of measure which relate to this particular aspect of layout. The proportions given here will be adequate for most works and are given as a point from which to start laying out text. They can be changed to suit a particular requirement, but remember, when changing the unit values, to allow more space at the foot so that the column of text does not look as if its slipping off the sheet area. Students always have some doubt when they first venture into the realms of layout and design but, with practice, they soon become proficient at decision-making.

Take a sheet 8¼in (210mm) by 5⅞in (149mm), which is known in the UK as A5, taken from the paper size A system (note pad size in the USA). A5 is used for leaflets and brochures. The A system is unique, as the sheet proportion remains in the same ratio even when folded in half or doubled up in size.

To decide on a text area, the width of the A5 sheet, 5⅞ (149mm), must be divided by 10 to obtain a unit width, that is 14.9mm. Round this up to the nearest whole millimetre, to 15mm. (Clearly, in this example it is easier to use the metric measure.) This will be the basic unit and it will be used to create the margins and text area of the sheet. One unit should be left at the head of the sheet, one unit for both the foredge and the spine and 1½ units at the foot. This leaves a text measure of 119mm in width and 172mm in depth. As a proportional system of arriving at a measure and depth of text, this principle of dividing by 10 and using the unit for margins works well on most sizes of sheet.

The size of text can be dependent on the amount of copy to be contained within the format, but emphasis here will be put on continuous text, as in a manuscript or booklet of several pages. The golden rule in continuous text lettering is that the optimum in readability is a line-length of ten words. In the English language this is equivalent to 60 characters, as the average word is six characters long, including word spaces. Therefore the line length can be between eight and twelve words, or 48 and 72 characters. Given this information a nib size

can be chosen to give approximately 60 characters to the line in the letter style decided upon. a typewritten manuscript can be easily fitted by counting the characters in one line, multiplying this by the number of lines and dividing the result by the number of characters contained within one line of the layout.

So let's take as an example 'my' using Roman Serif, and testing various nib sizes. Some interlinear space must be allowed to ensure that the ascenders and descenders do not clash. So letter a few lines with half a nib width and a nib width space before deciding on the latter. The depth of text will be 25 lines per page. Chose to range the text left. This in itself produces an inherent problem in that the right-hand margin will appear larger than the left, because of the ragged optical white space being protected. When producing the finished manuscript a minor adjustment for this will be made, by leaving more white space in the left-hand margin to compensate. In the end an extra ⅛in (3mm) is added to the left-hand margin.

An interesting demonstration of calligraphic style has been used by Ann Hechle to create her own business card (above left). The heavily flourished title is echoed in the single, smaller line of italic; these lines are alternated with other information written in a modern version of Rustic capitals. The design is centred on the card to rationalize the different line lengths and combination of styles.

Legibility is not a prime concern in this freely written alphabet, one of a series by Terry Paul (above). The main interest is the calligraphic properties of the forms in abstract terms, as a combination of line and mass. Careful attention has been paid to the balance of internal spaces and the extension of flourished strokes into the surrounding white space. This kind of experimental work, interesting in

its own right, is also good preparation for more formal writing since it accustoms the calligrapher to considering the overall layout of the lettering as well as its verbal message and individual details.

Ornamentation and Decoration

Linear decoration is the natural complement to handwritten text, whether it consists of extended pen movements flourishing the terminals of the letter strokes, or carefully drawn ornamental motifs designed to surround and mix with the writing lines. While there is a particular appeal in illumination using gold and colours, some of the most beautiful examples of early manuscripts are decorated with pen-drawn ornamentation only, and this can have a richness of texture that belies the simplicity of the technique.

The simplest form of elaboration is a fine hairline flourish extending or terminating a stroke, and this is extremely effective when a rapid twist of the pen turns a thick stroke into a fine hook or loop. The distribution of hairlines throughout an otherwise plain piece of lettering gives it variety and spontaneity – a lively texture that encourages the eye to travel along the design, whether it is a basic alphabet arrangement or regulated lines of text. More elaborate flourishing ranges from exaggerated looping of tails and ascenders to billowing masses of interwoven lines extending into the margins of the page, as was a common feature of copperplate writing samples, which were often heavily bordered with pen loops and curls.

Tone and texture are the key to balanced linear decoration in calligraphy. Black lettering on a page has an overall pattern and weight, depending upon the heavy or open character of the letterforms and the degree of variation

Calligraphy is often required for presentation pieces. Whenever a new certificate is introduced to replace a previous version (bottom right), an appointed scribe will have to experiment with various layouts before an acceptable form is selected. This is the redesigned certificate for the Royal Academy of Arts (top right), which was produced by the English calligrapher John Woodcock.

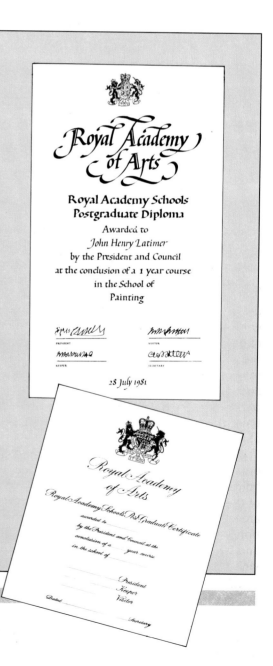

in design throughout the whole alphabet. In general, a satisfactory result in the elaboration of pen letters depends upon following through the consistency in the lettering design with regard to weight of stroke, thick/thin contrasts and the basic character of rounded, compressed or angular forms. Texturally, flourishes should balance and complement the overall pattern of the text rather than overwhelm it.

Additional decoration in the form of linear ornament can be constructed in abstract terms from this same appreciation of the true character of the letterforms and the tool with which they are written. Traditional forms of margin decoration often employ motifs culled from plants and other organic structures, and variations on vine patterns and similar tracery effects are

good companions for fine and medium weight scripts. Heavy lettering, such as Black Letter, requires equally consistent decoration.

Many styles of lettering design have been developed in the twentieth century in relation to advertising and display, which attempt to invoke particular associations with real objects or with an intended mood and feeling. In ornamental lettering, where the calligrapher can adapt forms to suit the pen stroke or moves beyond the basic pen stroke to the intricacies of built-up letters, there are many clues on colour, form and texture to be gained from the contemporary standards of all types of graphic design, as well as from the traditional excellence and sheer vitality of earlier forms.

Multiple stroke letters automatically acquire an ornamental appearance and in the case of this simple italic lower-case alphabet (above), the effect is exploited by drawing out the ascenders into the fluid, sailing loops. To maintain the evenness and consistency of the stroke pattern, a divided nib is used; these are available in many weights and thicknesses giving from two to five divisions of the stroke. A more skilful but infinitely more difficult and time-consuming approach is to build up the multiples from single lines.

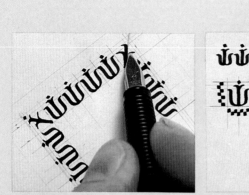

Deciding on the proportions of
the flower.

Designing the corner device.

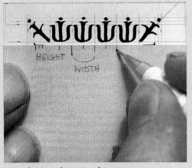

Transferring the unit values to a
strip of card.

Transferring the values from the
card to the finished surface.

The finished border used as an
'Ex Libris' for a friend's library.

Rules and borders

Decorative elements have been used to complement letterforms for almost as long as the written word has existed. Early manuscripts display decorative initials so elaborate in form as to lose the legibility of the character being embellished. Common sense and restraint must prevail and decorative enhancement play only a secondary role to that of communication.

When combining calligraphy with rules and borders, spare a thought for the compatibility between the letterform and the ornamentation. As letter styles have their place in periods of hisory, so too does decoration. Black Letter text with a 1920s border is not appropriate.

If asked to produce work that requires the use of borders, search a central library under the printing section. Sufficient reference will be found there not only for samples of 'flowers', 'arabesques', 'rules' and 'borders' (these are primarily printing terms), but also for the appropriate period to which they belong.

Alternatively the student can design his own borders. Do not be put off by thinking they are too complicated, as most borders, once analysed, can be easily reproduced, since they are based on the repetition of basic designs. For example, a simple border can be designed around a 'flower' (the decorative unit) and be contained within a square measuring seven nib widths by seven nib widths. This could be subdivided to give reference points for the beginning and ending of the various elements within the flower. This border may also require a 45° corner device, as it is not symmetrical, and possibly the foot of the flower might face inwards on each side of the border. The size of the border is established by multiplying the width and depth of the decorative unit.

For the cartouche and the tailpiece in a large border, preliminary work is carried out on tracing paper. Only a half or quarter of the image requires developing as the repetition is achieved by inverting or mirror-imaging the original drawing when tracing down on the finished surface.

fff4

Index

Numbers in italic refer to illustrations.

A
Aachen, 21
Airbrush, 35
Akken, *15*
Alcuin of York, 21, 70
Aleph, 16
Alexandria, 12
Alpha, 16
Alphabet, 10, 12, *12*, 15, 17, 19, *42, 51*, 121
 Black letter, *13*, 23, 24, 108, 113, 140,
 consonantal, 12
 Egyptian, 12
 Gothic, 23, *23*, 24, 25, 108, *108*, 113, *113*, 114, *114*
 Greek, 17
 Italic, *see* Italic
 Minuscule, *see* Minuscule
 Roman, classical, 6, *12, 56, 58*, 76, 84
 Renaissance form, 91, 92, *92, 93*
 square, 94, 100
 sans serif, 76–7
 serifed, *61*, 80
 uncial, *see* Uncial
 versal, *see* Versal
 vowel, 16
Ampersand, 74
Angle of pen, 44, 48, 49, 50, 53, *61*, 64, 76, 77, 80, 106, *106*, 125
Arabesque, 142
Arabic numerals, 70, 74
 scripts, 15
Arrighi, Ludovico degli', 25, 26
Artefacts, Roman, *18*
Ascenders, 20, *42*, 50, *51*, 52, 54, 70, 71, 73, 74, 80, *83, 88, 103,* 104, *111*, 116, *119*
Assurbanipal, *11*
Assyrian, *11*, 15
Augustus, Emperor, *16*
Ayres, John, 27

B
Babylonian, 10, 15
Bacciolini, Poggio (scholar), 24
Baker, Arthur, *42*
Basu, Hella, *29*
Beta, 16
Bible, 24
Biblical texts, 21
Bickham, George, *53*
Bishop, Dorothy (now Mahoney), *33*
Black letter, *13*, 23, 24, 108, 113, 140
 simple, 113
Blackboard exercises, *46*
Bobbia, 21

Book of the Dead (Egyptian), *14*
Books, Renaissance, 23
Borders, designing, 142, *142*
Boustrophedon, 16
Bowl (letter), 59, 60, 66, 71, 73, 74, 94, 121, 125
Boyajian, Robert, *37*
Broadside, 138
Bronze letter, *19*
Brush, calligraphy, 16, 42, 64, *93, 96, 96, 99*
 and pen, 17
 bamboo stem, *43*
 feather, *43*
 filling pen, 47
 hair lip, *43*
 reed, *43*
 roundhair, *42*
 sable, *42*
 sign-writer's, 42

C
Cancellaresca, 25
Capitals, 12, 114
 alternative, *102*
 height, *51, 81, 85, 101, 109, 117*
 Quadrata, 17, 24, 56, 58, 70, 84
 Roman, *19, 56, 61, 76, 76, 78,* 92, 94, 106, 126, 127
 modified, 94, 96
 Rustic, 17, 21, 70, 100, 127, *133, 139*
 scrolled, *55*
 serif, 116
 square, 6, *12, 13, 16,* 21, 94, 100, 133
Carolingian minuscule, *13*, 21, 24, 70, 90
Carstairs, Joseph (master), 27
Cartouche, 142
Chancery script, 25
Charlemagne, 21, 70
Chinese characters, 43
Chinese stick ink, *36*, 37
Chisel, 6, 17, 64, 76
Chisel-shaped tips, 33
Christian era, 17, 19, 20
Classical period, 15–19
Classical Roman, 25, 59, *84*, 96
Claudius, Emperor (arch of), *18*
Clay, soft, 11, 12
Cocker, Edward, 27
Codex books, 19, 20
Coins, Roman, *18*
Colophon, 21
Colours, mixing, 43
Consonantal symbols, 12, 15, 16
Construction, letter, *49, 56, 56, 113*
Control, pen angle, 48, 49, 53, 80
Copperplate, *13*, 26, *27*, 121, *121*
 engraving, 26
 nibs, *30*
 style, *55*, 121, 140

Copy books, 26, *27*
Cresci, Giovan Francesco, 26, 91, 92, *92*
Cretan, 15
Cross-stroke, 60, 66, 71, 127
Cuneiform, 11, *12*, 15, *15*
Cuneus, 11
Cursive, 24, 32, 106, *106*, 125
 black, 25
 italic, 25
 Roman, 25
Curved stroke, 50, 59, 93

D
Decoration, 26, 140–141, 142
 initials, 142
 linear, 140
 margin, 141
Demotic script, 11
Descenders, 20, *42*, 50, *51*, 52, 54, 63, 70, 73, 74, 80, *83, 88, 103, 104, 111,* 116, *119,* 133, 139
Design, *80, 121*
Dexterity, 50, 53
Diagonal strokes, 64, 73, 84
Display lines, centreing, *84,* 134, 136, *136*
Distilled water, *36,* 37, 43
Drawing pen, 30
Dürer, Albrecht, 113, *113*, 114
Dye, aniline, 36
 retouching, 37

E
Egg yolk, 43
Egyptian, 11, 12, 19
 alphabet, 12
 Old Kingdom, 15
Elizabeth I, Queen, 25
English half uncial, *13*, 104
 uncial, 104
Ephesus, *11*
Eraser, 33
Etching, 29
Etruscan, 16
Exclamation mark, 74
Exercises, 46, 50, 77, 80

F
Feathering, 37
Filling, pen, 47, *86*
Finishing stroke, 52
 flourished, *53*
Flourishes, *55, 99,* 114
Folio, 138
Foundational style, *33,* 80, 97, *106*

G
Gauge, marker, 54, *54*
Gilded, 21, *24, 25, 26,* 40
Glue size, 43
Gold leaf, *40*
Gospels, Latin, 20, *21*
 Lindisfarne, 21, *22,* 104
Gothic script, 23, *23, 24, 25,* 108,

 108, 113, *113*
 Black letter, 13, 23, 24, *32,* 108, 113, 140
 book, 26
 cursive, *13*
 flourished, 114, *114*
Gouache, 126
Graffiti (Pompeii), *18*
Grant of Arms, *23*
Greek, *11,* 12, *12,* 15, 16, 17, *18,* 19
Grid, proportional, 58–9, 60, 62, 63, 64, 66, 70–71, 74, 113
Grotesque (lettering), 76
Guide lines, laying out, 54, 77, 80
Gum arabic, 43
Gum sandarac, 41
Gutenberg Press, 24, 108

H
Hairline, 53, 108, *109,* 127
Half-uncial, 20, 21, 100, 104, 108
Handwriting, 25
Hebrew, 19
Heckle, Ann, *139*
Herodotus, 16
Hieratic script, 11
Hieroglyphics, 11, *11,* 12, *12,* 14, 19
Hittities, *11*
Hoefer, Karlgeorg, 29
Holy Roman Empire, 21
Horizontal strokes, 45, 48, 50, 56, 80
Humanistic, 24, 25, *123*
 italic, *13,* 123
 minuscule, *13*

I
Ideogram, 6, 10, 11, 12, *12,* 15
Illumination, text, *22, 24,* 43, 140
Inscriptions, carved, 16, *16, 17, 18, 19,* 68
Ingres paper, *38*
Inks, 32
 brand-name, 37
 carbon, 36
 colour, *29,* 37
 India, *76*
 non-waterproof, 37
 receipes for, 36, 37
 stick, Chinese, 37
 stone, *36*
 waterproof, 35
Insular script, 20
Interlinear space, 133
Iona, island of, 21
Ionic, 16
Iraq, 10
Irish Book of Kells, 21
 half uncial, 13
Islamic, 19
Italic, *26, 27, 31,* 52, 100, 116, *141*
 bastarda, 27
 fine, 121
 flourished, 121

 108, 113, *113*
 Black letter, 13, 23, 24, *32,* 108, 113, 140
 book, 26
 cursive, *13*
 flourished, 114, *114*
Gouache, 126
Graffiti (Pompeii), *18*
Grant of Arms, *23*
Greek, *11,* 12, *12,* 15, 16, 17, *18,* 19

formal, 125
 humanistic, decorative, *13,* 123, *123*
 lightweight, 116
 modern, 125
 nibs, *31*

J
Jackson, Donald, *40*
Japanese, 40
Johnston, Edward, 29, *33,* 37, 45, 46, 52, 80, 100, *106*
Foundational Hand, *33,* 80, 97, *106*

K
Kells, Book of, Irish, 21
Kennedy, John F., *76*
Kish, 10

L
Layout, 130, 131, *132, 133, 133, 134, 140*
 asymmetrical, 133, 135
 centred, *84,* 134, 136, *136*
 justified, 135
 optical centreing, 136
 ranged left, 134, 136
 ranged right, 134
 vertical alignment, 137, *137*
Layout pad, 38
Layout paper, 54, 77
Lebanon, 15
Left-handed, 30, *31,* 45
Letter forms, construction, 56, 58–9, 60
 proportion, 63, *63,* 64–8, 69
 round, 44
Letter spacing, *63,* 130, *130,* 131, 133
Lettering, Grotesque, 76
Library, Assurbanipal's Royal, Nineveh, *11*
Lightweight forms, 54, 123
Lindisfarne Gospels, 21, *22,* 104
Line, base, 54, 58, 63, 64, 73
 capital, 58, 64, 66
 centre, 66
 descender, 54
 interlinear, 54
 spacing, *76*
 writing, *41,* 52
 x-height, 54
Lithography, 29
Littera Antiqua, 24
Littera Bastarda, 24
Littera Moderna, 24
Lombardic style, 126, *126,* 129
Lower case, *33,* 50, 59, 70, 71, 84, 91, 93, 104, *106,* 116, *141*
 Roman, 91, 92, 93, 94
 modern, 99
 modified minuscule, 96
 Renaissance form, 91, 92, 93
 slanted, 99
Luxeuil, 21

143